UNDERSTANDING GREEK VASES

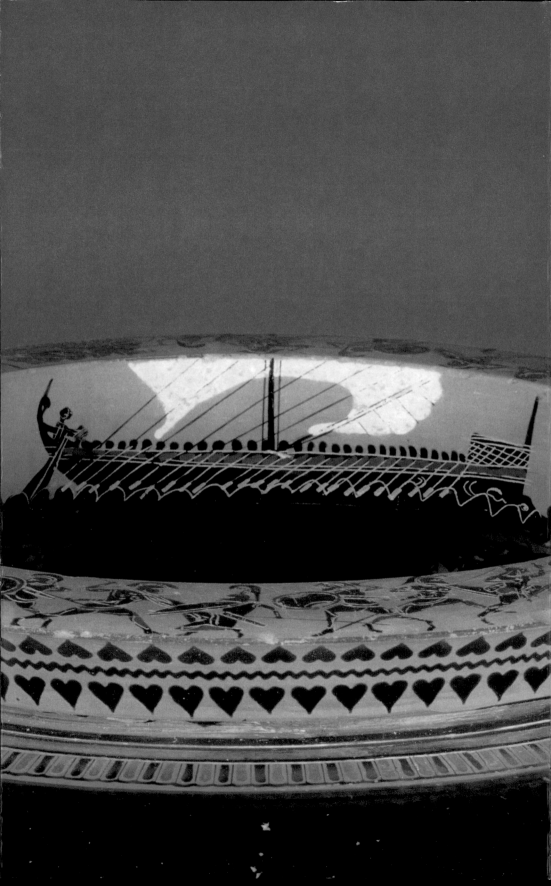

FIGURES 81–82.

DINOS

Attic black-figured dinos with stand. When the dinos was full of wine, the ships painted on the inside of the rim would appear to be sailing on a "wine dark sea." Attributed to the Circle of the Antimenes Painter, active 530–510. Diam (rim): 33 cm (13 in.); H of dinos without stand, 35.5 cm (14 in.). Malibu, JPGM 92.AE.88.

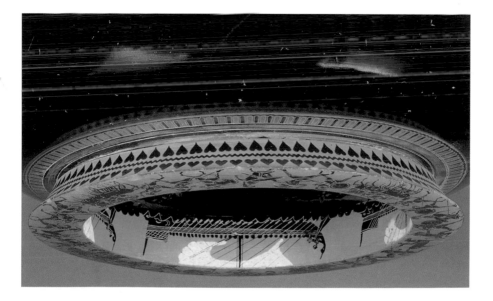

Defects/Flaws

The imperfections in the ceramic body or the GLOSS that occasionally occur during manufacture of a vase. Sometimes the gloss may have been diluted too much, resulting in a reddish rather than black color after FIRING; uneven temperatures in the KILN may produce similar changes. Red or brown areas and spots may likewise be the result of too low or too high firing temperatures. When vases that had not yet reached the LEATHER-HARD stage bumped together, this often caused dents or deformations in their shape. Cracks might occur at any time during the manufacture of a vase either because of a fault in the CLAY itself or because of air bubbles in the clay. Variations in the thickness of different sections of a vase might lead to cracking as well, due to differential expansion and contraction during drying, firing, or cooling, which all cause stress in the vase. Foreign particles in the clay may cause spalls—small chips that separate from the surface of the vase—due to expansion of those particles during firing. FIGURES 78, 79

Dilute gloss

The same black gloss as that used for the entire decoration of the vase, but diluted with water. The resulting medium fires to a translucent brown or golden brown color that appears to be applied with a very thin brush. Dilute gloss is used for rendering fine details and is especially effective for the delineation of anatomical features of figures, hair, or fine garments. FIGURES 50, 66, 80, 101

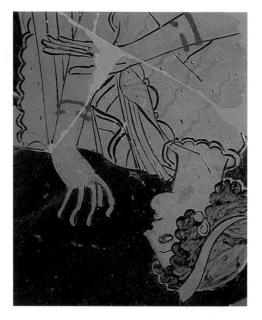

FIGURE 80.
Dilute gloss
The hair of this woman is painted with dilute gloss. Fragment of the interior of a red-figured PHIALE signed by DOURIS as painter, about 490–480. Malibu, JPGM 81.AE.213. Photo Maya Elston.

FIGURE 79.

DEFECTS/FLAWS

The light spot in the center of the panel is a dented and misfired area that was probably caused by this vase accidentally touching another vase inside the KILN. Detail of black-figured AMPHORA (Type B) attributed to the Rycroft Painter, about 520–510. Malibu, JPGM 86.AE.65.

FIGURE 78.

DEFECTS/FLAWS

Judge in athletic contest. Although this vase is generally a masterful demonstration of black-figure technique, mistakes in the application of the GLOSS may have caused the mottled surface visible on this figure. Detail of a PANATHENAIC PRIZE AMPHORA attributed to the Painter of the Wedding Procession and signed by the potter Nikodemos, 363/362 B.C. Malibu, JPGM 93.AE.55. (Cf. fig. 117.)

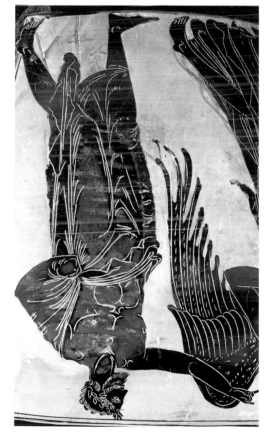

FIGURE 77. CORAL-RED

The Deeds of Herakles, with Athena seated in the middle. The entire body of this vase has been painted in coral-red. Red-figured volute-krater attributed to the KLEOPHRADES PAINTER, about 480–470. H (to rim): 49.7–50.6 cm (19⅝–19⅞ in.). Malibu, JPGM 84.AE.974.

CONSTRUCTION

In Archaic and Classical Greece only very large pots and unsophisticated housewares were formed by placing soft clay coils on top of one another and then smoothing the interior and exterior walls of the vase. In contrast, most of the ATTIC decorated vases discussed in this book were formed on a POTTER'S WHEEL. This included several steps: THROWING, JOINING, TURNING, and BUR-NISHING (for more information, see each of these entries). It is likely that the one-person foot-operated wheel was not used in Classical times; rather, a person other than the potter turned the wheel by hand, adjusting it to the desired speed, thus freeing the potter to use both hands to form the vase. FIGURE 76

FIGURE 76. CONSTRUCTION OF A VASE

ATTIC pottery workshop. To the far left two potters are completing a vase; next a potter and his assistant are turning a large vase on a wheel as part of the construction process (the pale section with the potter's legs has been digitally reconstructed by Maya Elston); in the middle a worker carries a vase toward a standing man, perhaps the owner of the workshop; to the far right a worker is tending the oven. Detail of shoulder of a black-figured HYDRIA attributed to a painter of the LEAGROS GROUP, about 520–500, Munich, Staatliche Antikensammlungen und Glyptothek 1717. Photo C. Moessner.

CONTOUR See OUTLINE, RELIEF LINE.

CORAL-RED

A paint occasionally applied to some ATTIC pots in the sixth and fifth centuries B.C. Coral-red was made by adding yellow OCHER to the black GLOSS; this made the gloss porous, which caused it to turn deep orange-red, or "coral-red" (rather than black) during the REOXIDIZING phase of firing. Because the coral-red gloss often did not adhere well to the surface of the vase, its use never became widespread, and coral-red was gradually abandoned. FIGURE 77

CORINTHIAN

Pottery from the city of Corinth, in the northern Peloponnese, where the black-figure technique of vase-painting was invented in the PROTOCORINTHIAN period (about 720–620). Corinthian vase-painting began in the third quarter of the seventh century B.C. It is characterized by ANIMAL-STYLE vases executed, particularly in its early phases, with careful attention to technique and detail (see fig. 60). The precision typical of the Protocorinthian phase yields in the Corinthian period to a preference for larger figures, often quickly inscribed and painted in increasingly larger fields, which in many cases leaves the entire vase available for decoration with a single figure, animal, or motif (see fig. 71). Evidently as a result of increased trade with the East, exotic hybrid creatures and monsters (Gorgoneion, Typhon, Triton, Boread, Mistress of Animals) joined the collection of more natural animals inherited from the Protocorinthian style. Corinthian CLAY is much paler than its ATTIC counterpart, and the typical effect of Corinthian vase-painting is achieved by the use of DILUTE GLOSS and abundant POLYCHROMY. FIGURES 71, 75

CUP See KYLIX.

UNDERSTANDING
GREEK VASES

A GUIDE TO TERMS, STYLES, AND TECHNIQUES

ANDREW J. CLARK MAYA ELSTON MARY LOUISE HART

THE J. PAUL GETTY MUSEUM
LOS ANGELES

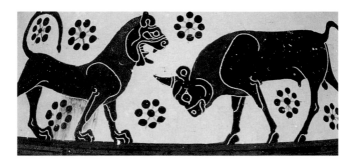

© 2002 J. Paul Getty Trust
Third printing

Getty Publications
1200 Getty Center Drive
Suite 500
Los Angeles, California 90049-1682

www.getty.edu

Christopher Hudson, *Publisher*
Mark Greenberg, *Editor in Chief*

Library of Congress Cataloging-in-Publication Data

Clark, Andrew J., 1949-
 Understanding Greek vases : a guide to terms, styles, and
techniques / Andrew J. Clark, Maya Elston, Mary Louise Hart.
 p. cm. — (Looking at)
Includes bibliographical references and index.
 ISBN-13: 978-0-89236-599-9
 ISBN-10: 0-89236-599-4
 1. Vases, Greek—Dictionaries. 2. Pottery—Technique. 3.
Vase-painting, Greek—Technique. I. Elston, Maya. II. Hart, Mary
Louise. III. Title. IV. Series.
 NK4645 .C57 2001
 738.3'0938—dc21

2001006214

Front cover: Fight between the gods and giants in upper
frieze; series of athletic contests or training scenes in lower
frieze. Detail of Attic black-figured volute-krater attributed to
the Leagros Group, about 510–500. Malibu, JPGM 96.AE.95.

Half-title page: Departure of Triptolemos. Detail of Attic
red-figured dinos attributed to the Syleus Painter, active
490–470. Malibu, JPGM 89.AE.73.

Title page: Attic black-figured dinos (detail). See fig. 81.

This page: Corinthian animal style (detail). See fig. 60.

Page 152: Nike crowning the victor in an athletic contest
(detail). See figs. 78, 95, 117.

Colophon: Herakles battling the Nemean Lion (detail). See
fig. 35.

Back cover: Youthful reveler. Detail of tondo of unattrib-
uted kylix (Type B), about 510–500 B.C. Malibu, JPGM
86.AE.280.

Contents

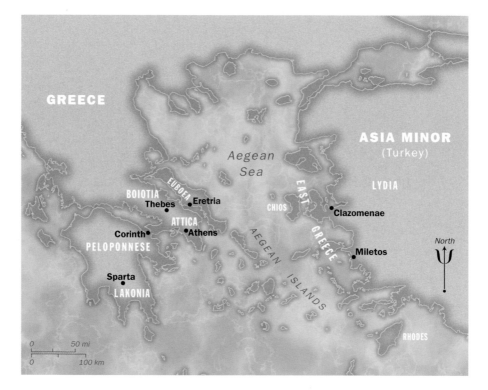

Greece, including East Greece, and the Aegean Sea.

Preface

Understanding Greek Vases is an expanded volume in the *Looking At . . .* series of technical guides published by the J. Paul Getty Museum. This series was designed to provide the general reader and museum visitor with a glossary-format introduction to the materials and techniques of the art they were "looking at." However, as the three of us worked through the variety of features comprising ancient Greek ceramics, we came to appreciate the unique qualities of this production that had, at separate times and in very different ways, originally inspired our shared fascination with it. We became sensitive to the particular needs of this topic and to the fact that the techniques of ancient Greek vases were so intrinsically tied to their artistic conception that they could not be properly introduced without an accompanying study of the stylistic patterns of their potters and painters. At the same time, it became evident that concise information on painters, techniques, materials, ornaments, styles, and shapes had never been available in a single small, illustrated volume. The philosophy and practice of conservation is also a topic of great interest, especially to museum visitors who want to know how vases are conserved, and how they can be reconstructed, sometimes from hundreds of fragments. Finally, although ancient Greek cultural history, subject matter, and iconography had to remain largely outside the scope of this book, we knew that since vases are the basis of much of what we know about ancient Greece, the images would require a brief introduction to this vast and fascinating field.

 Understanding Greek Vases thus is a more comprehensive book than others in this series. It begins with an essay by Andrew J. Clark on the historic and cultural context of the production and iconography of Greek vases, including a brief history of vase scholarship describing how and why vases have come to be studied. The essay on conservation, written by Maya Elston, includes previously unpublished information from the Museum's Department of Antiquities Conservation. Mary Louise Hart organized the illustrations for the book and wrote the "Glossary of Attic Potters and Vase-Painters." The authors teamed up to compile the "Glossary of Vase Shapes and Technical Terms," with Clark contributing the entries on vase shapes, ornaments, and writing; Elston the sections on the techniques of potting and painting; and Hart the definitions of stylistic and

art-historical terms. The chart of vase shapes was compiled by Elston and Hart and redrawn by Peggy Sanders. The bibliography is intended to provide references for further reading.

For reasons of clarity and focus, this volume contains only material from the Greek world. Because of this there are no entries on Etruscan, Chalkidian, Caeretan, South Italian, or any other ceramic material not from the physical environs of Greece and her islands. Unless otherwise noted, all works are Attic (from Athens) and all dates are B.C. While many of the ceramic types and artists are represented in the collection of the Getty Museum, we strove in every case to use the most applicable examples from collections in Europe and the United States. We are grateful to all the institutions that so generously supplied photographs; photographic sources are listed in the figure captions.

There are cross-references throughout all the texts to aid readers of every level: Words printed in SMALL CAPITALS refer to other entries in the book. Variants of shapes are listed under the shape's primary name; hence, the description of a neck-AMPHORA, for example, will be found in the AMPHORA entry. Additionally, a chronicle of the relationship of potters and vase-painters can be traced by following the cross-references from one entry to another, and to the "Looking at Greek Ceramics" essay. It is thus the intent of the authors that this small volume will provide the interested reader with an easily accessible survey of the significant facets of the materials, production, and conservation of ancient Greek ceramics.

We would like to thank the Curator of Antiquities, Marion True, and the Head of the Department of Antiquities Conservation, Jerry Podany, for their invaluable assistance and observations throughout the preparation of this manuscript. The curatorial support staff for the Antiquities Department provided welcome research and fact-checking assistance: We would like to thank Staff Assistant Monica Case for ordering photography; Curatorial Assistant Carrie Tovar for organizing the ORNAMENT entry and providing diligent research assistance; and Antiquities Intern Elizabeth de Grummond for research, proofing, and fact-finding assistance. We also wish to thank the external readers for their valuable comments on the text and illustrations. Finally, Andrew J. Clark would like to thank his wife, Joan, and his son, Benjamin, for their encouragement during the preparation of this manuscript.

A. J. C.
M. E.
M. L. H.

Chronology

Protogeometric	about 1050–900 B.C.
Geometric	about 900–720 B.C.
Protocorinthian and	
Protoattic black-figure	about 720–620 B.C.
Corinthian	about 620–550 B.C.
Early Archaic black-figure	about 620–570 B.C.
Archaic black-figure	about 570–530 B.C.
Late Archaic black-figure and	
red-figure	about 530–480 B.C.
Early Classical red-figure	about 480–450 B.C.
Classical red-figure	about 450–425 B.C.
Late Classical red-figure	about 425–300 B.C.
Hellenistic	about 300–30 B.C.

Abbreviations

BM	The British Museum
cf.	compare
DAI	Deutsches Archäologisches Institut
Diam	diameter
Gr.	Greek
H	height
JPGM	J. Paul Getty Museum
L	length
MFA	Museum of Fine Arts
MMA	The Metropolitan Museum of Art
no.	number
pl.	plural

FIGURE 1. *Komasts* (participants in a male drinking party). "As never Euphronios" is written behind
the dancer on the left. Detail of a red-figured AMPHORA (Type A) signed by EUTHYMIDES as painter,
about 520–510. H: 60 cm (23⅝ in.). Munich, Staatliche Antikensammlungen und Glyptothek 2307.

Looking at Greek Ceramics

By the beauty of their shapes no less than
their decoration they rank as works of art.
—GISELA M. A. RICHTER [1]

With the painting on the vase* finished, EUTHYMIDES looked at the figures he had drawn—two dancing men, and a third waving his walking stick—and decided what the finishing touch would be. He dipped his brush in purple-red paint, then wrote on the left side of the picture, next to one of the dancers, ὅσ οὐδέ-ποτε Εὐφρόνιος—"as never Euphronios," an enigmatic comment about his fellow vase-painter EUPHRONIOS, whose talent—either as a vase-painter or, less likely, as a dancer—Euthymides apparently claims to surpass (fig. 1).

These two vase-painters worked in Athens during the last quarter of the sixth century B.C. (about 525–500 B.C.), a time of great change and experimentation in Greek art. They were at the forefront of this trend, heirs to a continuous tradition of vase-painting that stretched back to the beginning of the GEOMETRIC period, about 900 B.C., when both patterns and figures were rendered in a linear style (see fig. 90). Vase-painting was set on a course then that, centuries later, led to the kind of painted pottery produced by Euthymides, Euphronios, and hundreds of other vase-painters.

In ancient Greece vases were commonplace: No one needed to be told what they were used for or what their pictures meant; pottery was just part of everyday life. Ceramic vases served as containers, either for utilitarian purposes in the home or for religious rituals. Some were decorated with figures and patterns, others were plain and painted black all over; unpainted coarse ware sufficed for cooking.

Here our concern is figured vases, with the focus on vases made in the region of ATTICA—dominated by the city of Athens and its environs—during the Archaic and Classical periods, roughly 620–300 B.C. Long known as Attic vases, they are today frequently called Athenian, after their principal place of manufacture. Pottery was made elsewhere in Greece, too, and in the glossary reference

*In the terminology of ancient Greek pottery studies, the word *vase* may refer to a ceramic vessel or container of any shape, including those that are partly sculptural, such as HEAD-VASES and RHYTA.

will be made to vases from other places—BOIOTIA, CLAZOMENAE, CORINTH, EAST GREECE, EUBOIA, and LAKONIA. The distinctive ceramics of the Greek cities in Southern Italy and Sicily, however, are outside the scope of this book.

In Athens, POTTERS and vase-painters worked in a number of areas, but mainly in the immediate neighborhood of the city's cemetery, which actually took its name, the KERAMEIKOS, from the fact that vases were made nearby: This *deme* (district) of Athens was called *Kerameis*. "Ceramic" is an adaptation of the Greek *kerameikos* (κεράμεικός, of pottery), which in turn comes from the word for potter's CLAY, *keramos* (κέράμος), which also means clay vase or pottery in general; *kerameus* (κεράμεύς) means potter (see figs. 69, 76, 122). From Athens vases were exported throughout the Mediterranean region—as far afield as Italy, France, Spain, Egypt, and Libya—and across the Black Sea to the Crimea.

Vases were produced in a broad range of shapes and sizes. Although each vase shape had its particular basic uses, those functions were also complementary. More than a dozen different shapes could be employed in connection with serving and consuming wine, as at the symposium, the male-only drinking party that followed dinner. The AMPHORA and STAMNOS were used for storage; the DINOS, KRATER, LEBES, or stamnos for mixing wine and water; the PSYKTER for cooling wine; the KYATHOS (or a metal ladle) and the OINOCHOE for serving the wine; and the KANTHAROS, KYLIX, MASTOS, RHYTON, or SKYPHOS for drinking it.

The vases were decorated by the painters, who worked in several techniques, of which the two principal ones are black-figure and red-figure. In both these techniques two colors predominate: deep orange-red and a shiny, metallic-looking black. Most Greek clays turn orange-red (often with a brownish hue) when fired (see FIRING), the principal exception being Corinthian clay, which is easily recognizable because it becomes yellowish white. Black is the color of the fired GLOSS with which the vases were painted.

The black-figure technique was developed by about 700 B.C. in Corinth: The figures were drawn in silhouette and the details either incised or added in colors. The technique was not adopted by vase-painters in Athens until about 620 B.C. Red-figure made its appearance about a hundred years later, invented in Athens about 530 B.C. Essentially it is the reverse of black-figure: The background is painted black, the figures are RESERVED, and, for the most part, details are drawn in black. A third technique in common use was WHITE-GROUND: The figures are drawn in OUTLINE on the whitened surface of the vase. For other techniques, see the glossary: ADDED COLOR, CORAL-RED, OUTLINE PAINTING, and SIX'S TECHNIQUE.

Of the principal techniques, black-figure in particular may appear strange to our eyes owing to its reliance on silhouette and incised details. But

the difference is illusory: Red-figure and white-ground are equally unrealistic, only we are more accustomed to them because they more closely resemble modern drawing.[2]

The limited number of colors seen on vases were by no means the only ones known to the Greeks, who employed a broad range of naturalistic colors in paintings on walls and wooden panels, very few of which have survived. Of the four colors seen on vases—black, orange-red, purple-red, and white—black and orange-red proved to be especially durable, like the fired clay itself, able to withstand the high heat of the KILN, the wear-and-tear of everyday use, and centuries of burial. Even breakage will not destroy vases completely; in fact, vase fragments can be both beautiful and instructive.

Greek vases are no longer everyday objects to be handled and used; rather, they have been deprived of their functionality and are now artifacts exhibited in museums, art galleries, and private collections around the world. Although the total number of Greek vases that survive today is unknown, upwards of sixty-five thousand Athenian vases are extant; still, this figure represents only a tiny fraction of the original production. Ancient Greek vases were known in Italy by the 1550s A.D., but although the first modern collections were probably formed in the mid-1600s, major collections of vases were not assembled until the early 1700s. In the eighteenth century, when vases were discovered in large quantities, they came to be valued especially for the insight they gave into ancient mythology and literature—an enduring importance of these vases.

At first the vases found in Italy were thought to be Etruscan rather than Greek. That they had been made by Greeks, however, was first proposed in the 1740s and then endorsed by Johann Joachim Winckelmann in his pioneering study of ancient art published in 1764.[3] Yet it was not until the INSCRIPTIONS on vases were recognized as Greek that this idea came to be accepted. The first public institution to display Greek vases was the British Museum, which in 1772 purchased the more than four hundred vases that had been collected in Southern Italy by the British ambassador to Naples, Sir William Hamilton (see fig. 42). The discovery, beginning in 1828, of thousands of vases in the Etruscan town of Vulci led to the important realization that both the inscriptions and the subject matter of some vases were not just Greek, but distinctively Athenian, or Attic. The impact of the Vulci discoveries also supported the efforts of the German antiquarian Eduard Gerhard, who in 1829 founded a learned society in Rome, which evolved into the German Archaeological Institute, still today a leading center for research in classical archaeology.

By the 1880s scholars had not only recognized the distinctive style of black- and red-figured vases from Athens but also distinguished pottery produced

elsewhere in mainland Greece, on the Greek islands, and in western Turkey (ancient Ionia), Southern Italy (Magna Graecia), and Central Italy (Etruria). Next attention focused on identifying the work of individual artists, studies based largely on vases signed by Athenian red-figure painters and potters. The German scholars Wilhelm Klein, Paul Hartwig, Adolf Furtwängler, and Karl Reichhold (see fig. 46) published landmark studies that accurately described and illustrated the work of many accomplished painters. In the twentieth century Sir John D. BEAZLEY, considered the foremost expert on Greek vases, definitively identified the work of hundreds of Athenian vase-painters using a method of comparative stylistic analysis that does not depend on signed vases alone (see SIGNATURES). Contemporary scholarship embraces all aspects of Greek vases—potting, painting, function, and subject matter—and examines the vases within the broad cultural context of Greek life and thought.

Looking at a vase begins with its shape, whose structure generally is likened to human anatomy: mouth, neck, shoulder, body, and foot—the handles the Greeks called ears. Pots were not always made in one piece but were thrown in separate sections that were joined together by the potter. The joints themselves are not apparent—not like seams on an article of clothing, at any rate—rather, the separate parts are usually betrayed by the slight changes in the contour of the shape: in other words, its architecture—the "interrelation of parts to the whole and to one another."[4] Observe the sections of the neck-amphora illustrated in fig. 59, a typical example of this shape: mouth and neck (thrown as one piece), handles (made separately and attached), shoulder and body (also thrown as one), and foot. The mouth and foot are the vase's upper and lower borders. In this instance both are black and of similar size, the diameter of the mouth being only a little larger than that of the foot. The neck-amphora's vertical handles, also black, are the side borders that mark the horizontal limits beyond which the figures in the picture do not extend. These relationships are not coincidental, but were very likely instinctive on the part of the painter, not planned anew for each vase. The vertical PATTERNS on the neck and under the figures are especially important, for they visually link the picture and the body to the adjacent parts of the vase, to the mouth and neck, above, and to the foot, below. Similar relationships can be discovered on most vases.

Nothing is more fundamental to the aesthetic of Greek vase-painting than the interplay and balance between the contrasting dark and light areas on a vase, that is, between the black painted areas and the orange-red of the unpainted clay. Look again at figure 59, but this time with the balance of dark and light in mind. The black is concentrated in the picture, and the picture dominates the vase. Observe, too, that the image is located on the widest part of the body and

takes up the most space on the vase. This position afforded the painter the largest surface on which to create the picture, and consequently the main pictorial zone occupies the widest part of most Greek vase shapes.

In black-figure, the picture is framed by patterns—sometimes on all four sides—as carefully divided from one another as the parts of the vase itself. In the case of an amphora potted and painted by EXEKIAS, the master of black-figure (see fig. 113.25), there is a palmette-lotus chain on the neck above the picture and small tongues on the shoulder; under the handles on the sides are palmettes intertwined with lotus buds; and below the picture, a key, lotus buds with dots between them, and rays. Within itself each patterned zone is balanced, composed of painted, that is, dark design elements and unpainted (light) areas; the vase is not literally half-dark and half-light, but it seems to be so.

Pictures in red-figure are framed by patterns, too: However, as red-figure develops, patterns become less and less important to the overall design. Sometimes there are no patterns at all, as on an amphora where nothing but black surrounds a singing poet (see fig. 22). The blackness calls attention to the contour of the vase and, more importantly, to the lone figure, who effectively counterbalances the black. More specifically, the blackness accentuates the movement of the figure: As he sings, his body sways back and forth, its rhythmic motion echoed by the way his garment billows around his feet and by the swirl of the cloth hanging from his instrument, a *kithara*.

More than any other element, the pictures are the most important decorations on vases. The Greeks delighted in images—men and women, gods and heroes, children, and all manner of animals or creatures—but their idea of realism was by no means identical to ours. They depicted human and mythological figures unceasingly, yet all but ignored representation of the world in which they moved: Landscapes and buildings are rarely more than isolated ancillary elements or essential props (see figs. 2, 7, 10, 20–21, 24, 28, 33, 34, 56). In vase-painting three-dimensionality was hardly a consideration: As a rule, figures have no shading to model their forms. Generally pictures have no substantial depth or perspective beyond the illusory sense of foreground and background created by overlapping or by arranging figures on more than one level (see figs. 40, 42, 44), the latter a development inspired by large-scale Athenian wall-paintings of the fifth century B.C., none of which has survived.

It is the story-telling aspect of a vase-painting, however, that readily captures our imagination. This is true especially when the picture is dramatic, such as the one inside a kylix where we witness Tekmessa's discovery of the dead body of the Greek warrior Ajax (fig. 2). Although Ajax was the strongest of the Greeks who participated in the Trojan War, he did not die gloriously in battle. Tragic

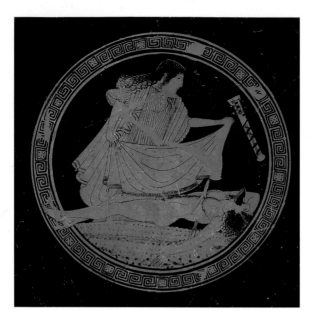

FIGURE 2. Tekmessa covering the corpse of Ajax. TONDO of a red-figured KYLIX (Type B) attributed to the BRYGOS PAINTER, about 490. Malibu, JPGM 86.AE.286.

events beyond his control forced him to commit suicide: Ajax set his sword upright in the pebbly beach at Troy and threw himself upon it.

The impact of a narrative picture such as the suicide of Ajax depends on the vase-painter's talent for detail and, in a successful picture, every detail makes sense. There is no better example than another picture illustrating the Trojan War: the removal of the corpse of Prince Sarpedon from the battlefield by the winged brothers Sleep and Death (fig. 3). In the center is the god Hermes. All the figures are identified in writing, and the vase is inscribed with the signatures of the potter, Euxitheos, and the painter, Euphronios. What makes this picture exceptional is not only the complex and beautifully detailed figures—especially the anatomy of Sarpedon—but also the fact that his body is actually in motion. He is being lifted up and carried to the right, as Euphronios indicated by the leftward flow of blood from Sarpedon's wounds. Realism of this kind seems strikingly modern and is, admittedly, highly unusual in vase-painting. Who can say whether or not an ancient Greek would have recognized such subtlety?

Despite the self-evident beauty of such vase-paintings, however, it is essential to remember that decorating vases was a repetitive craft, and the routine work of most vase-painters was skillful but not necessarily inspired. They all worked within the constraints of a formalized and often formulaic art. On the one hand, it would be wrong to think that every vase-painter was an artist in the sense the word is used today, that is, an individual with a highly developed, personal style that often expresses a personal point of view. The concept was unknown

and possibly unimaginable to the ancient Greeks. In fact, they had no word for art as we understand it: The closest term was *technē*, which meant skill or craftsmanship. On the other hand, the styles of vase-painters are recognizable—primarily on the basis of the details of their drawings—and the best painters rise above the level of craftsman: They are artists in the modern sense, whether or not they themselves would have recognized it.

Black-figure, especially about 575–530 B.C., often favored the sensibilities of the miniaturist. Meticulous, delicately incised details and patterns predominated, a kind of miniaturism seemingly inherent in the character of the incised line itself. The AMASIS PAINTER—who chiefly decorated small vases—was an exquisite minaturist, and his example will stand for others of this ilk: SOPHILOS, KLEITIAS, Nearchos, and the Tleson Painter. An OLPE by the Amasis Painter displays his gift for the diminutive in the finely detailed figures of Perseus, the Gorgon Medusa, and the god Hermes (fig. 4). For the Amasis Painter, miniaturism often goes hand in hand with symmetry, which, likewise, is an important design element in black-figure. The picture on the olpe is one example of symmetry, but the principle is more rigorously applied on an amphora where Dionysos is

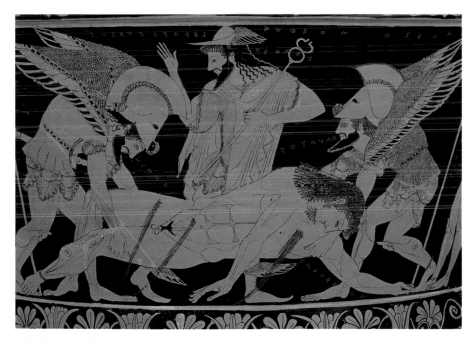

FIGURE 3. Death of Sarpedon. INSCRIPTIONS label Sarpedon, Sleep (Hypnos), Death (Thanatos), and Hermes. Above, *Leagros kalos* is written RETROGRADE; the SIGNATURE of Euphronios as painter begins to the right of Hermes' cap. Detail of a red-figured calyx-KRATER signed by Euxitheos as potter and by EUPHRONIOS as painter, about 520–510. New York, MMA, Bequest of Joseph H. Durkee, Gift of Darius Ogden Mills and Gift of C. Ruxton Love, by exchange, 1972, 1972.11.10. © 1999 MMA.

attended by youths who bring foxes and hares and pour wine for the god (see fig. 19). In that picture the symmetry of the figures has a discernible, measured cadence—the alternation of youths and animals, evenly spaced on either side of Dionysos—and to a degree the rhythm is echoed by the palmette-lotus festoon in the space above. Miniaturist details and deliberate symmetry combine to impart a quiet mood to this encounter of the human and the divine.

Not all black-figure painters were miniaturists. LYDOS was one of the first to draw full-bodied, muscular humans, energetic characters that inhabited "action" pictures (see fig. 37); his figures may best be described as monumental or statuesque. Exekias, who was a younger contemporary of the Amasis Painter, made the "Lydan" figure style his own and brought it—as well as the black-figure technique—to full flower. Exekias's figures are more human than any others in black-figure, and his talent for fine incision is unsurpassed. In his picture of the brothers Kastor and Polydeukes with their parents the figures are not stiffly graceful like the Amasis Painter's; they move easily and naturally, as illustrated in figure 5, where Polydeukes bends down to greet a dog, and their mother, Leda, proffers sprigs of myrtle and a flower. As those figures demonstrate, it is normal in vase-painting for gestures to be more eloquent than facial expressions. Even though Exekias's faces are very restrained, it is impossible to overlook the fact that his people have feelings.

The monumental figure style of Lydos and Exekias was continued by the painters of the LEAGROS GROUP and by the LYSIPPIDES PAINTER to about 500 B.C. From black-figure it was transmitted to red-figure, readily observable in the work of Euthymides and Euphronios (see figs. 1, 3). It seems an inescapable conclusion that the fluidity of the painted line in red-figure—especially the all-important RELIEF LINE—encouraged increased naturalism. Nowhere is this better illustrated than in the work of ONESIMOS: He was a realist who was not shy about depicting life as he saw it. His figures move with ease; their faces verge on, and sometimes enter into, the expressive. On the inside of a wine cup, for example, the consequences of heavy drinking are not downplayed: a man vomits, bent over in pain and leaning on his walking stick (fig. 6).

In the early decades of the fifth century B.C.—about 490–470—other painters likewise cultivated realism: the BRYGOS PAINTER (see figs. 2, 11, 23), DOURIS (see figs. 26, 58, 102, 115, 130), the Foundry Painter, and MAKRON (see fig. 38), who, like Onesimos (see fig. 16), were all cup-painters, as well as the KLEOPHRADES PAINTER (see figs. 33, 77, 131), a decorator of larger pots. Douris stands somewhat apart from the others. His figures appear serious-minded and purposeful, their bodies strong yet not overly muscular. In one of Douris's characteristic pictures, a young man standing behind an altar pours a libation for a

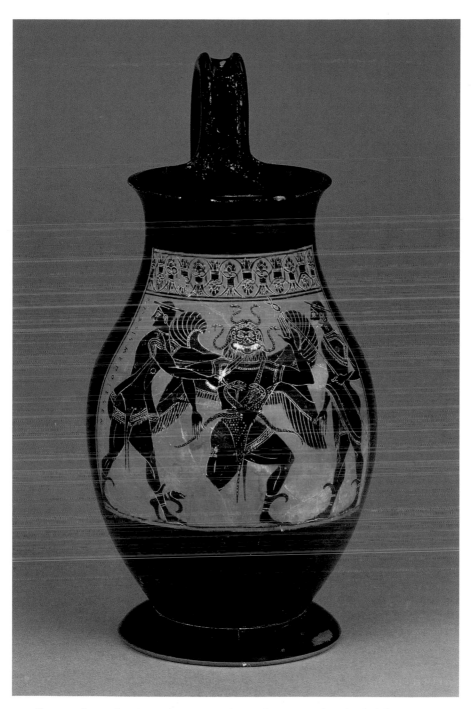

FIGURE 4. Perseus decapitating the Gorgon Medusa, with Hermes on the right. Black-figured OLPE
signed by Amasis as potter (vertically at the left border), and attributed to the AMASIS PAINTER,
about 540–530. H (to rim): 20.9 cm (8¼ in.). London, BM B 471. © BM.

FIGURE 5. Kastor and Polydeukes with their parents. Black-figured AMPHORA (Type A) signed by EXEKIAS as potter and painter, about 530–520. Vatican, Museo Gregoriano Etrusco 16757.

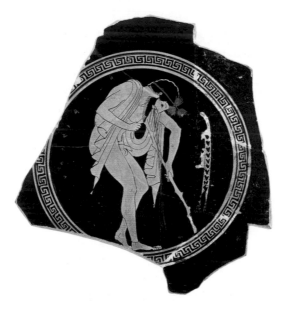

FIGURE 6.
Man vomiting.
Fragmentary TONDO
of a red-figured KYLIX
(Type B) attributed
to ONESIMOS, about
500–490. Greatest
extent: 15.9 cm
(6¼ in.). Malibu,
JPGM 86.AE.284.

seated, regal-looking older man (see fig. 26). It is a serene image and, as is so often the case with Douris, the figures resemble statues: they are stately and restrained. This statuesque style takes hold among many of the leading painters of larger pots too—the BERLIN PAINTER (see fig. 22), the Syleus Painter (see half-title page), and the NIOBID PAINTER (see figs. 44, 45)—and prevails even beyond the middle of the fifth century.

Beginning about 450–440 B.C. many vase-paintings have a meditative or solemn mood, sometimes verging on sadness. On smaller shapes, such as Nolan amphorae or lekythoi, the pictures usually consist of two figures, balanced images epitomized in the work of the ACHILLES PAINTER. On one of his many white-ground LEKYTHOI a departing warrior holds out his helmet toward a seated women (see fig. 18). They gaze in one another's direction, yet their eyes do not meet; the figures are all but motionless: a wordless encounter in a place of stillness. Both figures are painted in outline, which is standard on white-ground lekythoi, and the thin lines of dilute gloss—golden brown in color—seem exceptionally graceful and expressive. Of the painters who decorated larger vases such as kraters, several admirably carried on the statuesque figure style of earlier days, which continued vigorously until about 400 B.C.: the PHIALE PAINTER (see figs. 49, 118–19), POLYGNOTOS (see fig. 51), the KLEOPHON PAINTER (see fig. 32), and the DINOS PAINTER (see fig. 25).

After the time of the Achilles Painter—in the last quarter of the fifth century B.C.—red-figure remained technically accomplished and, from a certain standpoint, became increasingly beautiful. The painted line became freer and the figures, in general, more active. There is delicacy and lyricism in this kind of drawing, especially in the finely detailed hair and garments with which the painters endowed the figures. The MEIDIAS PAINTER best exemplifies this. He is, it seems, the last influential Attic red-figure artist, and he had many imitators. One of them decorated a small lekythos crowded with figures: an affectionate couple in the center—presumably Helen of Troy and her lover, Paris—flanked by two women and, flying above, a tiny chariot pulled by two Erotes; an awkwardly depicted door behind the couple places the scene in an interior space (fig. 7).

Attic red-figure continued into the fourth century B.C., lasting for about a century after the Meidias Painter. Some painters carried on the ornate drawing style of the late fifth century B.C., while others worked in a plainer mode. The last decades of the fourth century saw one final display of inventiveness: red-figured vases were embellished extensively with white, pastel colors, details in RAISED relief, and even GILDING (see figs. 40, 91, 96). The overall effect is dazzling but unlike all that came before. By about 320 or, at the latest, by 300 B.C., figured vases stopped being made in Athens. The style of the late fifth century B.C., however,

had been successfully transplanted about 430 B.C. to the Greek cities of Southern Italy and Sicily, where a new tradition of red-figure vase-painting flourished for more than a century.

Of all the myths, legends, gods, and goddesses depicted on Greek vases, it is possible here to call attention only to a very few. No myths were more popular than the exploits of Herakles, a hero who possessed strength beyond all mortals due to the fact that his father was Zeus, king of the gods. Herakles was an ancient Greek superhero—the bravest adventurer and the ultimate athlete—yet that is only part of his significance. As a man, Herakles had a life full of daunting struggles and fantastic achievements, for which he was rewarded by the gods with immortality. Worshiped as a god, his place in Greek religion was analogous to that of a Christian saint, a sympathetic intermediary between the mortal and divine realms.

Among the twelve Labors for which Herakles was best known, his first was represented more often than any other: killing the lion of Nemea (see fig. 35, colophon page). This is just one of many legends in which a Greek hero defeats a powerful animal or a mythical monster: stories of adventure—not unlike our own fairy tales—that may also be regarded as symbolic conquests of the malignant forces of nature. Other myths of this kind include the beheading of Medusa, one of three monstrous Gorgons, by the young Perseus (see figs. 4, 51); and the slaying of the Chimaira by Bellerophon, a prince of Corinth, assisted by his winged horse Pegasos (see fig. 103).

Such stories usually compelled the hero to overcome a particular difficulty. Perseus, for one, had to contend with Medusa's power to turn men to stone with her glance. Bellerophon had to outmaneuver the Chimaira's three menacing heads (lion, goat, and snake). In the case of Herakles, the Nemean lion's skin was invulnerable to weapons, thus forcing the hero to fight the animal with his bare hands. On vases he is usually depicted wrestling the beast to the ground, with the lion caught in a stranglehold and Herakles about to choke it to death (see fig. 77, far right). Even after death the lion's skin retained its invulnerability, so Herakles often wore it as a protective garment, using the lion's head as his helmet and wrapping the skin around his body like armor or holding it out like a shield (see figs. 20–21).

Other deeds commonly appearing on vases include Herakles killing the many-headed Hydra (see figs. 71, 77), a fearsome monster who quickly grew new heads to replace any that was cut off; his visit to the Garden of the Hesperides (see fig. 42); and his battles with the Amazons (see fig. 138), formidable warrior women said to inhabit the Black Sea region, who were among the vase-painters'

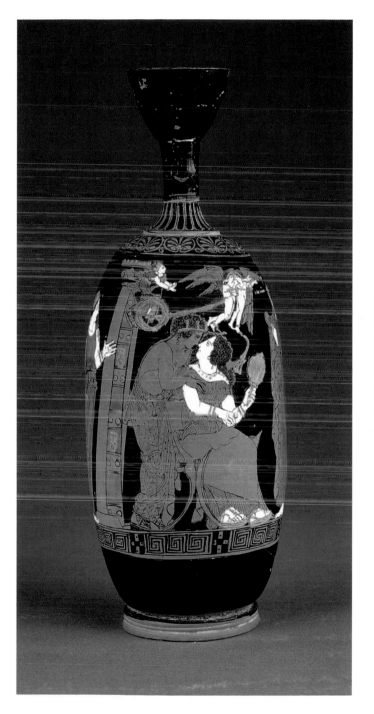

FIGURE 7.
Helen and Paris. Red-
figured LEKYTHOS
attributed to the
Painter of the
Frankfurt Acorn,
about 420–400.
H: 18.5 cm (7¼ in.).
Malibu, JPGM
91.AE.10.

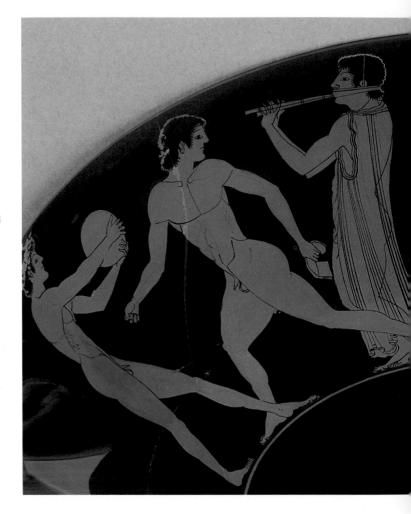

FIGURE 8.
Athletes. Detail of
exterior of red-figured
KYLIX (Type B)
attributed to the
Carpenter Painter,
about 515–510.
Malibu, JPGM
85.AE.25.

favorite subjects (see figs. 48, 121). Frequently the goddess Athena is beside the hero, her presence assuring his victories (see figs. 71, 77). After Herakles' death, Athena accompanies him to his new home among the gods on Mount Olympos.

As the goddess of Athens, Athena appears regularly on Attic vases, most notably on PANATHENAIC AMPHORAE, where, flanked by columns, the goddess strides aggressively forward, ready for battle (see fig. 117). This Athena, perhaps her most familiar image, probably depicts a statue of the goddess on the Acropolis. Among the contests depicted on the backs of these amphorae (presumably the games for which the prizes were won), the most common ones are men running (naked or in armor), jumping, boxing and wrestling, throwing the discus and javelin, and chariot racing. Sometimes the judges are shown (see

fig. 78). Athletics, which taught many skills useful in war, was a fundamental part of a boy's formal education, which might take place at home or in the gymnasium (fig. 8), or *palaistra* (wrestling school).

Only the wine god Dionysos surpasses Athena in popularity in vase-paintings, which is not surprising, given the many vases designed for preparing, serving, or drinking wine (dinos, kantharos, KOTYLE, krater, kyathos, kylix, psykter, rhyton, skyphos, stamnos). Dionysian pictures are by no means limited to these shapes, however. Usually the god is seen (generally holding a kantharos of wine) with his mythical male and female companions—satyrs and nymphs—or with his mortal female followers—maenads—but often the god, or his image, is attended or worshiped only by his mortal followers (see figs. 19, 25, 38).

Sometimes he is seen standing alone or reclining on his dining couch under a grapevine; from time to time the deified Herakles keeps him company. It is very common to find satyrs, maenads, or ordinary women depicted by themselves, engaged in Dionysian pleasures such as drinking, dancing, musicmaking, or sex (see figs. 43, 93, 109). Even if the god is not with them, his spirit still motivates them. Dionysos is also the god of the theater, which, in common with other Dionysian pursuits, belongs to the realm of imagination and intense experience (see fig. 52). Vase-paintings of performances—tragedies, comedies, and satyr plays or parodies—depict both the actors and the chorus, often in costume or masked, and they sometimes include elements of the stage or scenery. Representations of Greek theater are especially common on vases made in South Italy.

One cannot divorce the imaginary, mythological world from reality: the two are intertwined. The realm of myth is but the creation of the human mind and, to a degree, a reflection of human life. Moreover, gods and goddesses are very frequently seen in vase-paintings not just with heroes but also with ordinary mortals. It may be almost impossible to determine what motivated a vase-painter to choose a particular mythological subject—for we have no ancient sources that give us such information—but more than enough is known about the Greeks to detect some of the everyday-life associations of mythological pictures. Because the Greeks did not depict historical events but, rather, thought in terms of mythological metaphors, the Trojan War was linked in the Athenian mind with the wars fought with the Persian Empire (490–480/479 B.C.) or with the Peloponnesian War (431–404 B.C.), which pitted Athens against Sparta and her allies. Every soldier, therefore, could be regarded as an Achilles. In a like manner, any athlete was another Herakles. On the other hand, in the male-dominated Greek world an Amazon represented the exact opposite of an Athenian woman: violent or uncontrolled female behavior was a Greek male's nightmare.

Scenes from the Trojan War were also very popular subjects for vase-painters (see figs. 2, 3, 16, 24, 33, 34, 46, 55). The war offered them a wide range of subjects for decorating their pots: incidents from the *Iliad* and the *Odyssey* plus many recounted in ancient books that have not survived, as well as incidents known only from vase-painting (see figs. 29, 59). The Trojan cycle of myths begins—long before the events narrated by Homer—with the marriage of the mortal Peleus to the sea goddess Thetis (see figs. 31, 40). At the wedding (attended by all the Olympian gods) the goddesses Hera, Athena, and Aphrodite argued about which one of them was the most beautiful. Unable to decide for themselves, they called on the Trojan prince Paris to be the judge. However, Aphrodite rigged the contest by bribing Paris with the beautiful Helen, who was the wife of King Menelaos of Sparta (the episode is known as the Judgment of Paris: see

figs. 96, 128). It was the ill-fated love of Paris and Helen (see fig. 7) and their sub-sequent elopement to Troy (see figs. 107, 112) that caused the Greeks to set sail in the *Iliad* to fight for her return. The ensuing war (see figs. 2, 3, 23, 24, 29, 33, 34, 46, 55), culminated in the total destruction of Troy by the Greeks (see figs. 16, 33), after which they returned home, with Odysseus the last to be re-united with his family. For the Greeks, the Trojan War was more than a thrilling legend. It was accepted as a historical narrative in which the principal heroes— especially Achilles and Hektor—embodied the high moral values of their society: nobility, achievement, honor, and glory.

More often than not, vases depict the world of the male citizen and the aristocratic class—although there are many exceptions. Most vases depict youths (shown as beardless, or just old enough to have long sideburns) and men (bearded, as a rule), but boys are not uncommon. Physical types departing from the male norm are infrequent but include old men, foreigners, blacks, and dwarves.

Many pictures illustrate aspects of the *symposium*, a male drinking party at which the company reclined on couches, or the *komos*, a rowdy procession of the participants (see fig. 1). Although the symposium was a setting for poetry and serious conversation—some of Plato's dialogues take place in this context, for example—on vases it is drinking, dancing, musicmaking, and sex that occupy the men and youths at these events (see figs. 27, 72, 101). A favorite game of symposiasts was *kottabos*, the object of which was to hit a target with wine dregs that were flung out of a kylix. The preparation, serving, and drinking of wine is frequently represented, as are sometimes the unpleasant effects of intoxication, which have already been mentioned (see fig. 6).

In pictures of the symposium, sex of all kinds is portrayed, often graph-ically. Sexual activity is also frequent in the gymnasium, as well as in other con-texts. Heterosexuality and homosexuality (see fig. 74) were both commonplace, and masturbation as well as transvestism are among the subjects depicted by vase-painters. They did not shy away, either, from illustrating urination (see fig. 111) and defecation. The women often present at the symposium are known as *hetairai* (literally, "companions"); they were paid for their services, and they are variously depicted engaging in sex, playing the *aulos* (double flute) or the lyre, and dancing.

The fact that war was a permanent feature of life is made clear by the abundant images of mythical and contemporary battles. Youths and adult men are seen putting on their armor (see fig. 126); leaving their families and depart-ing for war (see fig. 32); sailing away on ships (see fig. 81); riding in chariots (see figs. 79); fighting as *hoplites* (heavily armed foot soldiers), archers, or cavalrymen (see figs. 24, 30, 127); passing the time during lulls between battles (see figs. 29,

59); killing the enemy or dying on the battlefield (see figs. 2, 3, 16, 33, 34, 48); and, for the fortunate ones, returning home (see fig. 5).

Some of the most engaging vase-paintings show men at work rather than at war, although such pictures are less frequent, perhaps, than one might expect. Scenes of farming depict plowing and sowing, picking grapes and olives, as well as pressing olives and making wine. Other agrarian pursuits include fishing and hunting. Among the craftsmen represented are metalworkers at a forge, bronze-workers assembling a statue, a carpenter working with an adze, and a doctor treating patients. Other pictures allow us to glimpse butchers or a shoemaker at work, and a youth buying oil or vases (fig. 9). Not unexpectedly, there is a number of pictures of potters and vase-painters (see figs. 69, 76, 140). One vase shows a woman working in a shop where vases are being decorated (see fig. 140, far right), though what she is doing remains uncertain. Of all the known names of potters and painters, none is feminine.

Certainly the Greeks enjoyed looking at themselves, at least as much as we do today. On vases they saw themselves—at close range, for vases were made to be handled—going about their everyday activities. Typical male pursuits included athletics and sports, which are depicted very frequently. On one kylix, for example, young athletes train to the rhythmic beat of a flute-player's music: two

FIGURE 9.
Youth buying vases in the KERAMEIKOS; his purse is in his left hand. TONDO of a red-figured KYLIX (Type B) signed by Phintias as painter, about 520–510. Baltimore, The Johns Hopkins University Archaeological Collection B 4.

discus throwers, two jumpers, and a youth wielding a pickaxe to break up the hard earth of the playing field (see fig. 8). Females inhabited a more mundane realm. On a HYDRIA, women fetch water from a fountain house, which was both a social occasion and a daily chore: Three women fill their hydriai from the animal-head spouts; one seems to wait, balancing her hydria on her head; and another, who has no hydria, gestures as she converses with her companion (fig. 10). The events depicted on these two vases are more than mere illustrations of the commonplace; they epitomize the fundamentally different lives of Athenian men and women: Action and competition were the prerogatives of men, domesticity and subservience that of women.

Greek women and girls led a secluded life at home, bound by strict rules of propriety (to which the *hetairai* and others of their ilk were exceptions). On vases women pursue domestic duties: fetching water at the fountain house and spinning are the most typical. Oddly, they are only rarely shown cooking or preparing food; men and youths are sometimes seen engaged in these activities, which are then generally thought to be aspects of religious rituals.

More often than not women are seen in the company of other women and engaged with attendants, children, and babies. Apart from their household responsibilities, women are often represented grooming and primping, preparing for marriage or in a wedding procession (see figs. 28, 104), and participating in the worship of Dionysos (see figs. 25, 38). Both men and women are depicted in various religious activities: pouring a libation (see figs. 26, 32), making a sacrifice at an altar, mourning the dead (see fig. 108), and visiting tombs in the cemetery.

Girls are sometimes seen at play on a swing or a seesaw. On a number of vases from Brauron, north of Athens, girls take part in the initiation rites of the cult of the goddess Artemis located there. Many of the representations of toddlers and babies appear on *choes* (see oinochoe, shape 3), where the children are shown playing with their toys and pets.

Animals were an integral part of Greek life, too, and both real and mythical beasts are everpresent in vase-painting. On Corinthian and East Greek vases in particular, animals—not people—take center stage (see figs. 60, 61, 75, 139); lions, bulls, boars, panthers, deer, goats, birds, and sphinxes predominate. Although largely relegated to secondary roles in Attic vase-painting, animals are, nevertheless, ubiquitous (lions, figs. 35, 55, 63, 77, 108, 124, 126; boar, fig. 63; panthers, fig. 138; birds, figs. 24, 37, 50). Horses are regularly depicted because of their close relationship to man, unmatched by any other animal (see figs. 5, 24, 30, 31, 34, 45, 46, 54, 55, 71, 77, 79, 108, 112, 121, 124, 127). In addition to the animals already mentioned, the following are often encountered: dogs (figs. 5, 36, 47), hares (figs. 19, 24, 36), donkeys (fig. 135) and mules, owls,

snakes (figs. 34, 42), and fish (fig. 89). Less common are camels, cats, crabs (fig. 71), and insects (scorpions, grasshoppers, and cicadas).

While the imagery on Greek vases is extremely varied, vases offer neither a complete nor a balanced view of the society. Few of the many slaves and foreigners who resided in Athens are depicted. Women and children are shown only in a very limited number of roles; pictures of family life are rare. Except for isolated examples, the ugly, the infirm, and the elderly are unseen. The very active political and intellectual life of the Greeks is almost entirely absent; images of famous persons are virtually unknown, and no contemporary events of any historical significance are depicted. These are significant gaps; nevertheless, what vase-painters chose to portray shows us so much of their world in lively, intimately detailed, and often remarkably beautiful pictures: vase-paintings enable us to experience ancient Greece with our own eyes.

<div align="right">A. J. C.</div>

NOTES

[1] G. M. A. Richter, *Shapes and Names of Athenian Vases* (New York, 1935), p. xi.

[2] J. D. Beazley, *The Development of Attic Black-figure* (1964; rev. edn. Berkeley and Los Angeles, 1986), p. 1.

[3] J. J. Winckelmann, *The History of Ancient Art*, 4 vols. (first German edn. Dresden, 1764; first English edn. London, 1849–1873), trans. G. H. Lodge (Boston, 1880), pp. 265–66, 269.

[4] G. M. A. Richter, *Attic Red-figured Vases: A Survey* (rev. edn. New Haven and London, 1958), p. 11.

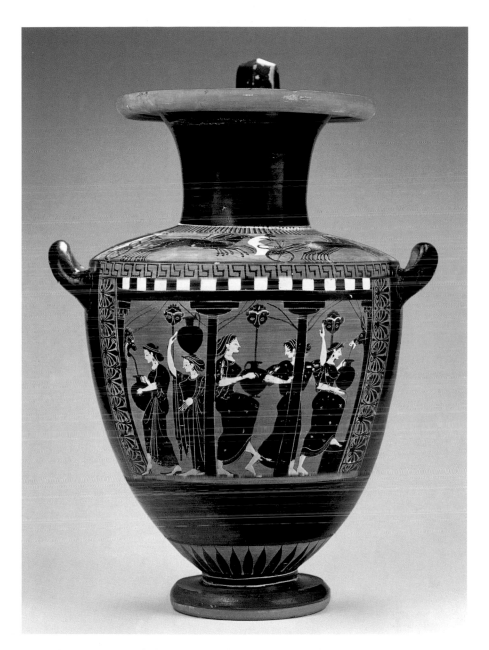

FIGURE 10. Women fetching water at the fountain house. Black-figured HYDRIA attributed to the Priam Painter, about 520. H: 53 cm (20⅞ in.). Boston, MFA, William Francis Warden Fund, 61.195. Courtesy, MFA, Boston. Reproduced with permission. © 2000 MFA, Boston. All rights reserved.

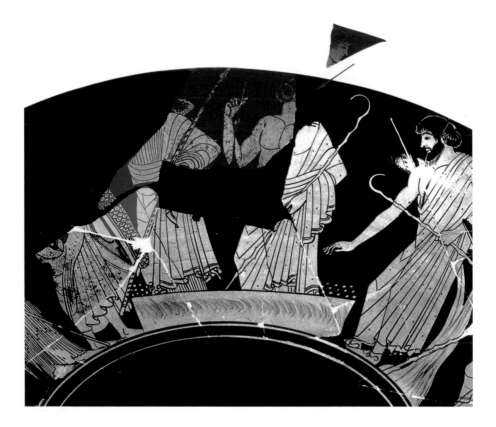

FIGURE 11.
Example of digital
documentation of a
series of fragments
that were inserted into
a KYLIX in 1986 and
1996; accession
numbers refer to
specific fragments.
Detail of red-figured
kylix (Type B)
attributed to the
BRYGOS PAINTER,
about 490. Malibu,
JPGM 86.AE.286.
Digital documentation
by Susan Lansing
Maish. (See fig. 23
for the finished
restoration.)

FRAGMENTS INSERTED 1986 WITH DIFFERENT ACCESSION NUMBERS

89.AE.58

FRAGMENTS INSERTED 1986

85.AE.481.2

85.AE.19.B

FRAGMENT INSERTED FEBRUARY 1996

90.AE.24.4

Conservation and Care of Ancient Ceramic Objects

Only rarely does a ceramic artifact survive intact from antiquity. Most ancient ceramics come from burial environments and are broken into numerous fragments that may be covered with dirt, insoluble incrustation, or harmful soluble salts. For that reason, conservation is almost always required.

The purpose of conservation is to preserve cultural and artistic properties, that is, to reduce or, preferably, stop their further deterioration by adequate treatment and environmental control. Many functions, however, are included under this general statement: examination and analysis of the artifact, technical investigation and research, documentation, structural stabilization, consolidation and assembly of the object, compensation for losses, aesthetic integration of the entire surface, storage and climatic conditions, mounting and display, and monitoring the results of treatment.

Some principles and philosophical issues are fundamental to the field of conservation. For instance, the principle of reversibility requires that any treatment of an object be reversible, that is, the object could be returned to its pre-treatment condition if needed. Other principles state that particular signs of aging should not be removed or concealed. Damaged or weathered sections must not be disregarded, and the object must be conserved and preserved as a whole. Widely accepted ethical and philosophical codes hold that reconstructed sections should be readily distinguishable from original material, thus respecting its authenticity. Abiding by these codes assures the preservation of historical evidence intrinsic to each object and allows a basis for futher studies.

Conservation begins with determination of the cause, nature, and degree of damage; the object is examined, and the condition of its surface and structure is assessed. The result of the examination will determine methodological approaches and the extent of treatment or, in some cases, only assess condition. All data gathered during examination and analytical work are recorded and filed as a condition report. An object condition report includes both a written report and photographs, graphic drawings, and/or digital documentation (fig. 11) reflecting the state of the object before, during, and after treatment.

Several techniques of nondestructive evaluation are used to reveal significant details of the surface and assess the structural condition of the object.

Magnifiers or optical microscopy are employed using various sources of light: normal and raking light, flexible fiber-optic lighting, ultraviolet and infrared illumination, or X-radiation. Further identification of material composition is provided by examination of minute samples (microsamples) in a scientific laboratory. Several analytical tests, among them electron microprobe analysis (EMPA), neutron activation analysis (NAA), energy dispersive X-ray fluorescence spectroscopy (EDXRF), atomic absorption spectroscopy (AAS), inductively coupled plasma atomic emission spectroscopy (ICP), X-ray diffraction analysis (XRD), and thermoluminescence (TL) dating, provide important information that may also be decisive for the future treatment or assessment of the artifact. TL dating, for instance, is an effective means of detecting forgeries in cases where the age of an artifact is questioned.

Depending on the results of the examination, a conservator can select one of two approaches: preventive or interventive. While conservation in most cases is interventive (or active), in some cases preventive (or passive) care in the form of stabilization, monitoring of climatic conditions, and avoiding unnecessary handling may be sufficient to protect the object from further deterioration. Interventive treatment is selected for objects that are in an active state of deterioration, structurally unstable, or whose fragmentary condition prevents readability, understanding, and evaluation of their artistic quality. Since problems with individual objects vary greatly, conservation treatments range from cleaning and removal of soil and dirt from the surface of an intact vase to the complete reconstruction of a piece that has been shattered into many fragments.

Cleaning removes dirt, stains, incrustations, and other foreign matter from the surface of a vase or fragment through chemical or physical procedures (fig. 12). Dirt and incrustations are removed mostly by careful, controlled mechanical cleaning with a variety of surgical tools or soft and hard brushes to remove layers covering the original surface. Because these procedures are irreversible, they should be considered very carefully. The layer of deposits found on fragments contains information about the soil or the site where the object was originally buried; once removed, this information is lost. Cleaning is generally considered in cases where the layer has a substantial thickness that obscures surface information, thus making the object unreadable or aesthetically unsightly. Saving samples of removed material as well as careful documentation and analysis of these samples helps preserve information intrinsic to the individual object or fragment.

Cleaning is usually carried out under a binocular microscope in order to monitor the work in greater detail. It is also crucial to remove all deposited material from broken edges, for if the object is to be reconstructed, it will be hard

FIGURE 12.
Incrustation on the
surface of an ancient
vase. The areas at
the upper left and
lower right show the
original surface after
mechanical removal of
the thick incrustation
layer. Detail of a red-
figured AMPHORA
attributed to the
Geras Painter,
480–470. Malibu,
JPGM 79.AE.139.
Photo Antiquities
Conservation
Department, JPGM.

to obtain the correct position of joins if soil or other foreign particles are left on the broken surfaces.

Similar conflicts about reversibility are encountered with consolidation, a step that may be irreversible to some degree. For the safety of the object or for its readability, returning it to its preconservation state may not be desirable; nevertheless, it is critical to select the right type of treatment from the start. Stabilization and consolidation may be carried out prior to cleaning if objects are in such a degraded state that it is impossible to handle them safely. While stabilization is usually applied to lift an object from the excavation site, consolidation is generally carried out to reinforce and to prevent flaking layers of GLOSS or surface from detaching. This is done by introducing a consolidating material (or consolidant) into the ceramic structure to the desired level of penetration.

One of the most deleterious effects on ceramics is caused by soluble salts, which usually come from the burial environment. Soluble salts may penetrate low-fired and porous wares in particular; the salts dissolve and crystallize, expand and contract during atmospheric changes, causing pressure, exfoliation, or even disintegration of the pottery (fig. 13). Desalination procedures carried out during

FIGURE 13.
Magnification of
salt formation on a
terracotta surface.
Photo Antiquities
Conservation
Department, JPGM.

conservation can remove or significantly reduce the concentration of harmful soluble salts in the ceramic structure.

When a sufficient number of fragments of a vase are extant and can be joined, it is worthwhile reconstructing the vase (fig. 14). When damage or loss is too extensive, the object may not be appropriate for reconstruction or display, since there is a high probability of creating a misleading interpretation. In such cases in particular, collaboration between conservators and art historians is essential for a full understanding of the meaning and complexity of the original design of a vase. The conservator must be very cautious about the correct placement of any individual fragment, especially "floating" fragments that have no contact with any other fragments. Proper alignment of fragments is achieved by careful observation and technical evaluation of physical properties such as color variations, design, mechanical fit, THROW lines and TURNING marks, and thickness variations and alteration due to aging. The mechanical fit may be very difficult if the edges are too weathered, were sanded down during a previous restoration, or have been incompletely cleaned. Furthermore, the conservator has to take into account any potential interaction between the ancient ceramic and modern conservation materials. The choice of conservation materials is of great importance; they must be stable, chemically neutral, and readily soluble in common solvents, that is, it must be possible to readjust or remove every fragment.

Missing sections of a vase are restored in a variety of ways. Filling both assures structural stability and provides an uninterrupted surface for the final integration. Extensive damage may require fabrication of a shell that precisely replicates the original shape of the vase (figs. 15, 16). This requires obtaining precise measurements of the profile of extant fragments, producing templates,

1

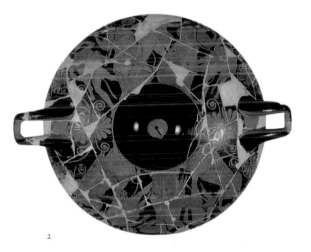

2

3

FIGURE 14.
KYLIX (Type C)
attributed to
DOURIS as painter.
1 Disassembled
fragments of the kylix
before treatment.
2 Kylix during
treatment: white
areas are modern fills.
3 Exterior of the kylix
after completion
(foot is a modern
reconstruction). The
Cleveland Museum
of Art, Hinman B.
Hurlbut Collection,
508.15. Photos Maya
Elston.

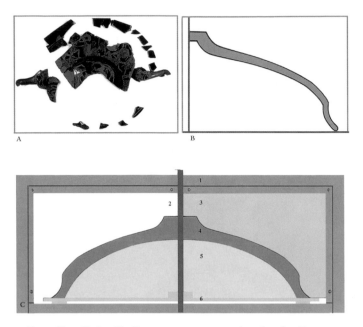

FIGURE 15. KYLIX (Type C) signed by EUPHRONIOS as potter and attributed to ONESIMOS as painter, about 490. Rome, Villa Giulia 121110 (formerly JPGM, 83.AE.362). *A* Fragments of the kylix before treatment. *B* Drawing for the profile of the kylix. *C* Cross-section of the reconstruction form placed on the spinning equipment: *1* Wooden construction. *2* Rotating rod. *3* Acrylic template for exterior. *4* Synthetic shell. *5* Layer of Plasticine. *6* Rotating acrylic disk. Photo and graphics Maya Elston.

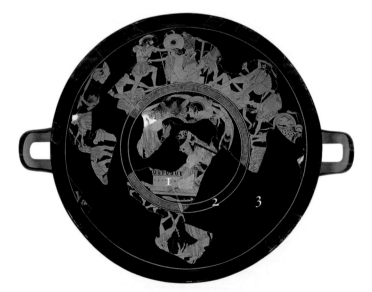

FIGURE 16. Interior of reconstructed KYLIX figure 15 with more original fragments inserted in the lower section. Diam: 46.6 cm (18⅜ in.). *1* Original surface. *2* Concentric circles painted on the reconstructed area to show the division of the rim, figural compositions, and the central area of the tondo. *3* Area of modern fills.

and turning a vase in a synthetic material by a method similar to turning a vase on a POTTER'S WHEEL. Only when sufficient original fragments are preserved can this be done.

While the predictable shape of a wheelmade vase can easily be repeated, a PLASTIC figurative vase may be reconstructed only if satisfactory references are available for the same shape (fig. 17). Although the issues surrounding display of a vase vary from one museum or collection to the next, as a rule arbitrary or speculative propositions are avoided. This applies also to the reconstruction of missing handles or feet of vessels; whenever possible, MOLDS and casts for them are made from the object itself.

Once a fragmentary vase has been reconstructed, an effort is made to minimize the impact of losses that disturb or diminish the visual unity and integrity of the object. To this end the modern fills are painted in sympathetic colors, thus unifying the entire surface of the vessel while it is still clear what parts are modern (see fig. 16). Although simple or repetitive decorative elements may be painted over the modern additions to unify the appearance of the vase, sections of figures and details of the composition are not usually re-created, for they would be too interpretive or even hypothetical.

Ceramic wares, although generally durable, are highly susceptible to mechanical shock. Handling should therefore be kept to minimum. The goals of conservation work are to stabilize the condition of the artifact, to preserve historical evidence, to select safe treatments that will not exclude future intervention and interpretation, to present the object effectively by integrating the surface and improving its readability, and, finally, to provide a stable and benign environment.

M. E.

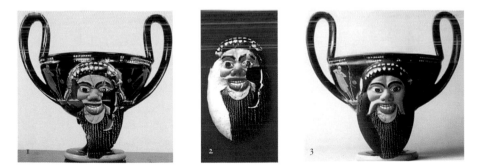

FIGURE 17. Red-figured KANTHAROS with a satyr mask possibly molded by EUPHRONIOS (cf. fig. 110 for the other side of this vase). *1* Before reconstruction; large sections are missing from both sides of the satyr's face. *2* After the vase is disassembled, missing sections are reconstructed according to corresponding areas that survive elsewhere on the vase. *3* The satyr mask completed. H (with handles): 21.1 cm (8¼ in.). Malibu, JPGM 85.AE.263.

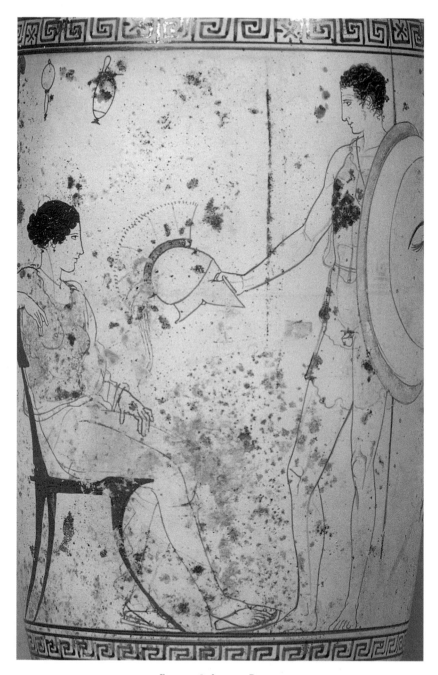

FIGURE 18. **ACHILLES PAINTER**
Departure scene: Warrior and woman. Detail of WHITE-GROUND LEKYTHOS attributed to the Achilles
Painter, about 440–435. Athens, National Museum 1818.

Glossary of Attic Potters and Vase-Painters

ACHILLES PAINTER (active 470–425 B.C.)

A prominent red-figure painter, the Achilles Painter is known also as the leading painter of WHITE-GROUND funerary LEKYTHOI during the high Classical period (mid-fifth century). He was a pupil of the BERLIN PAINTER, from whom he learned a graceful linear style. His name comes from the commanding figure of Achilles, the greatest hero of the Trojan War, whom he depicted on a red-figured AMPHORA now in the collections of the Vatican Museums. FIGURE 18

AMASIS PAINTER (active 560–520 B.C.)

A potter who signed his vases Amasis—a name of Egyptian origin—produced a wide variety of shapes, and he most likely painted the vases as well. The Amasis Painter's style evolved from the miniaturist tradition of KLEITIAS. Yet while the style is typically Archaic in its combined attention to detail and to precise drawing, the Amasis Painter's best work is vivaciously executed and imbues his figures, mortal and divine, with a distinct energy. FIGURES 4, 19, 113.7

ANDOKIDES PAINTER (active 530–515 B.C.)

The Andokides Painter, named after a potter SIGNATURE on an AMPHORA now in Berlin, was one of the early practitioners of red-figure; in fact, he has often been credited with inventing the technique. A number of his pictures appear on BILINGUAL vases, that is, vases that have red-figure on one side and black-figure on the other. The black-figure work on these bilingual vases has been separately attributed to a prolific follower of EXEKIAS called the LYSIPPIDES PAINTER. The two artists thus had an extremely close collaboration, and it is possible that they were one and the same person. FIGURES 20–21, 65, 72, 87, 127

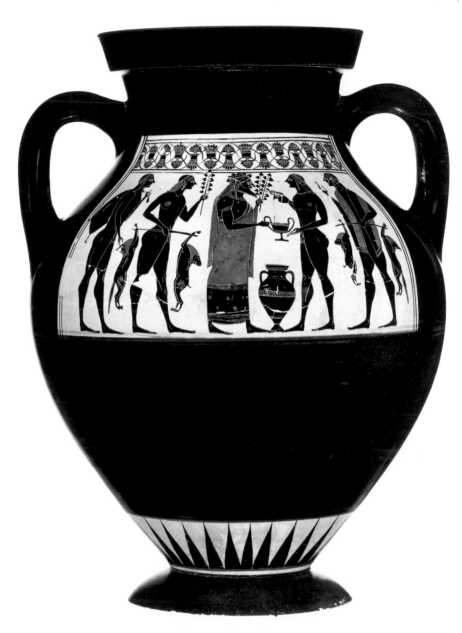

FIGURE 19. **AMASIS PAINTER**
Dionysos and youths: Dionysos holds out his distinctively large KANTHAROS to a youth who pours wine into it from an OINOCHOE. The AMPHORA that stored the wine stands between them. Black-figured amphora (Type B) attributed to the Amasis Painter, about 540–530. H: 42 cm (16½ in.). Munich, Staatliche Antikensammlungen und Glyptothek 8763.

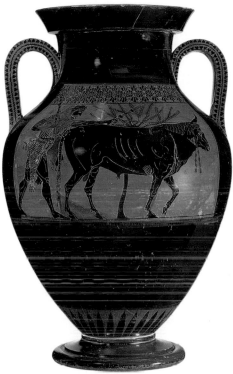

FIGURES 20–21.
**ANDOKIDES/
LYSIPPIDES PAINTER**
Herakles on his way
to sacrifice a bull.
BILINGUAL AMPHORA
attributed to the
Andokides/Lysippides
Painter, about 525–
515. H: 53.2 cm
(20⅞ in.). Boston,
MFA, Henry Lillie
Pierce Fund, 99.538.
Courtesy, MFA,
Boston. Reproduced
with permission.
© 2000 MFA, Boston.
All rights reserved.

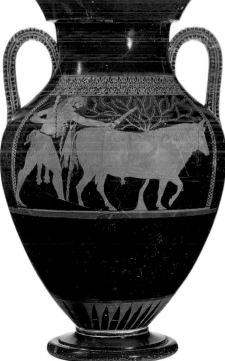

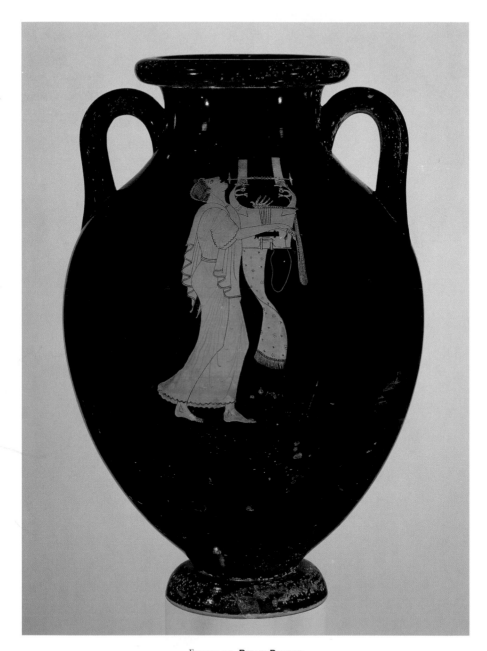

FIGURE 22. **BERLIN PAINTER**
Rhapsode (singing poet). Red-figured AMPHORA (Type C) attributed to the Berlin Painter, about 490.
H: 41.5 cm (16⅜ in.). New York, MMA 56.171.38. © 1998 MMA.

BERLIN PAINTER (active about 500 to 460s B.C.)

Often paired with his contemporary the KLEOPHRADES PAINTER as representing the culmination of Late Archaic red-figure painting on large vases, the Berlin Painter is remarkable for his pictures of a single figure set against the frameless black background of a vase, without the traditional framing ORNAMENTS. While he does not avoid multifigured compositions and indeed renders them with equal skill, his predilection for the single figure emphasizes the elegant linearity of his drawing style. His name derives from an AMPHORA with Hermes, a Satyr, and a Faun, now in Berlin. FIGURES 22, 129

BRYGOS PAINTER (active 480s–470 B.C.)

With DOURIS, ONESIMOS, and MAKRON the Brygos Painter was one of the leading CUP-painters of the first generation after the PIONEERS. The style of his work is close to yet not derived from that of Douris, and he seems to have trained in the WORKSHOP of Onesimos. He painted a broad range of subjects: mythological and Trojan themes, legends of the gods (especially Dionysos), and both the revelry and quietude of daily life. Whether his compositions are still or energetic, his figures demonstrate psychological awareness through pose and gesture. He excelled at composing on the convex surface of the cup exterior, where figures engaged in dancing, fighting, and living move in complicated pyramidal groupings. His name derives from several cups ATTRIBUTED to his hand that are all signed by Brygos as potter. FIGURES 2, 11, 23, 93, 113.17, 113.19, 135

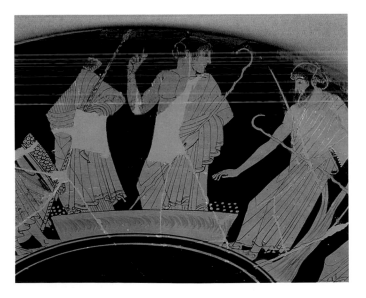

FIGURE 23.
BRYGOS PAINTER
The Vote for the Arms of Achilles. Detail of red-figured KYLIX (Type B) attributed to the Brygos Painter, about 490. Malibu, JPGM 86.AE.286. (For the reconstruction of this vase, see fig. 11.)

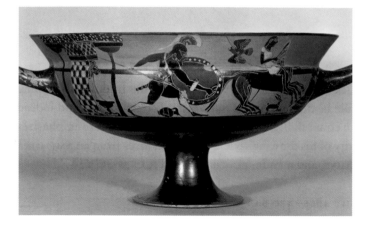

C PAINTER (active around 575–560 B.C.)

Named by BEAZLEY for the "corinthianizing" character of his work, the C Painter was the preeminent painter of Siana CUPS in the second quarter of the sixth century B.C. Fond of military panoply, he was the first painter in Athens known to have depicted the Birth of Athena (springing full-grown from the brow of Zeus) and the Sack of Troy. The C Painter's style is characteristic of early ATTIC black-figure: still significantly influenced by CORINTHIAN miniaturism and ADDED COLOR, yet invigorated by energetic, striking poses and bold gestures used to communicate narrative. FIGURE 24

DINOS PAINTER (active 430S–410S B.C.)

A contemporary of the MEIDIAS PAINTER, the Dinos Painter carried the monumental painting tradition of POLYGNOTOS through to the end of the fifth century B.C. Like the KLEOPHON PAINTER, who may have been his teacher, the Dinos Painter favored large figures on large vases (such as his NAME VASE, a DINOS now in Berlin), a tradition that was continued by the PRONOMOS PAINTER. The Dinos Painter's preference for active movement does not prevent his figures from exuding a calm intensity. On a dinos now in Naples, mortal women dance in swirling garments, lost in a state of divine ecstasy, while on the other side of the vase, maenads prepare to worship Dionysos. For all the figures, the Dinos Painter communicates religious and psychological tension by clothing solid figure drawing with the voluptuous style of the Meidias Painter. FIGURE 25

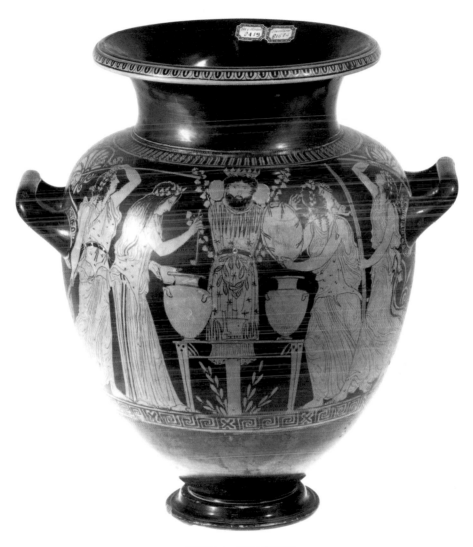

FIGURE 25. **DINOS PAINTER**
The worship of Dionysos. Red-figured STAMNOS attributed to the Dinos Painter, about 420.
H: about 49 cm (19⅝ in.). Naples, Museo Nazionale Archeologico H2419.

ATTIC POTTERS AND PAINTERS 37

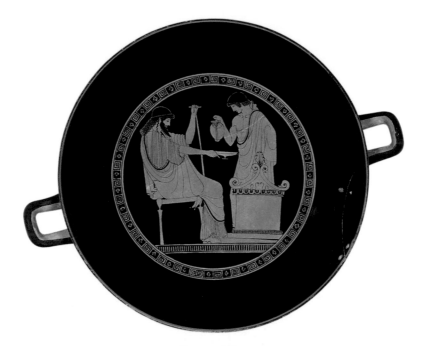

FIGURE 26. **DOURIS**
Young man pouring wine from an OINOCHOE into an older man's KYLIX (Type B), perhaps Ganymede and Zeus. Interior of a red-figured KYLIX (Type B) by the potter Python, signed by Douris as painter, about 480. Diam: 32.4 cm (12¾ in.). For the exterior of this kylix, see figures 58, 102, 130. Malibu, JPGM 84.AE.569.

DOURIS (active approximately 500–470 B.C.)

Over three hundred vases have been ATTRIBUTED to this painter, who signed his name on more than fifty of them. Together with the BRYGOS PAINTER, ONESIMOS, and MAKRON, he was one of the leading red-figure CUP-painters of the Late Archaic period (530–480 B.C.). On the exterior of CUPS Douris often drew energetic, active figures, yet his drawing is always controlled and in strong contrast to the more exuberant style of the Brygos Painter (cf. figs. 2, 11, 23, 93, 135). Stillness and serenity are Douris's hallmarks, best illustrated by his masterful TONDO pictures, as well as by his WHITE-GROUND LEKYTHOI. FIGURES 14, 26, 58, 102, 113.18, 113.20, 115, 130

EPIKTETOS (active approximately 520–490 B.C.)

Probably a pupil of PSIAX, Epiktetos was a BILINGUAL painter who was trained as a black-figure artist but produced his best work in the TONDI of early red-figured CUPS and PLATES, which were his specialty. Exteriors of his cups are often all black, thereby focusing attention on the figured tondi inside. Epiktetos signed his name on more than forty vases. FIGURE 27

ERETRIA PAINTER (active approximately 440–410 B.C.)

The lush, graceful drawing of the Eretria Painter contrasts with the style of his contemporary the KLEOPHON PAINTER, corresponding more to that of the slightly younger MEIDIAS PAINTER. Though best known for his work on CUPS, the Eretria Painter did his most interesting work on shapes such as the CHOUS, the squat LEKYTHOS, the OON, the amphoriskos, and the EPINETRON. Because of its unique association with women, the epinetron was often decorated with scenes presumably meant to appeal to women. In figure 28 the delicacy and grace of the painter's drawing is in harmony with the intimate character of his subject. We see Alkestis relaxing with her attendants after her wedding to Admetos. Although these figures are mythological, a contemporary Athenian bride's wedding day must have been much like this, both in appearance and in feeling. The painter is named for an EPINETRON from Eretria (see figs. 28, 84). FIGURES 28, 84, 112

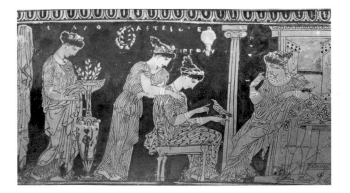

FIGURE 28.
ERETRIA PAINTER
Alkestis (on the right) after her wedding to Admetos. Detail of red-figured EPINETRON attributed to the Eretria Painter, about 425. Athens, National Museum 1629. © DAI Athens, neg. no. NM 5126.

EUPHRONIOS (active 525–500 B.C.)

An early and prominent red-figure PIONEER. In contrast to EUTHYMIDES, Euphronios preferred carefully arranged compositions of multiple figures on large vases. On one of the most famous ATTIC vases to have survived—a calyx-KRATER now in New York—he painted the slain Trojan hero Sarpedon being transported from the battle by Sleep and Death (see fig. 3). Using distinctively massive figures to convey the narrative in two-dimensional space, Euphronios renders the dead hero with exceptional grandeur. Showing his knowledge of and pleasure in WRITING (see pp. 1, 6), Euphronios has clearly labeled the epic characters. Later in life he turned from painting to potting, at which he was equally skilled. Among his masterworks is the largest Type C CUP known (see fig. 16), as well as a number of PLASTIC VASES (see fig. 110). Euphronios's SIGNATURE is preserved on more than twenty vases. FIGURES 3, 16, 17, 101, 110

EUTHYMIDES (active 525–500 B.C.)

With EUPHRONIOS, Euthymides was one of the major PIONEERS of early red-figure vase-painting and the teacher of the KLEOPHRADES PAINTER. Euthymides' style is typified by three-figure compositions on large vases that allow for explorations of figural movement in space. He often chose subjects that allowed him to experiment with complex poses, such as athletes or dancers, in contrast to Euphronios's more grandly conceived tableaus. Seven vases are known with the signature of Euthymides. FIGURE 1

EXEKIAS (active 545–530 B.C.)

Often called the greatest black-figure artist, Exekias was trained in GROUP E. He signed vases both as potter and as painter; as potter he is credited with inventing the calyx-KRATER, a favorite of red-figure vase-painters because the large area available for decoration is well suited for depicting a continuous narrative frieze. Exekias's mastery of the black-figure technique, particularly INCISION, is unequaled. He was a painter of heroes, as demonstrated by his well-known AMPHORA in the Vatican on which he painted a scene of Achilles and Ajax playing a board game during a break in the Trojan War (this scene was, perhaps, invented by Exekias). In scenes such as this, and in his depiction of Ajax preparing to commit suicide, Exekias shows himself to be an insightful master of psychological tension. FIGURES 5, 29, 113.25, 120

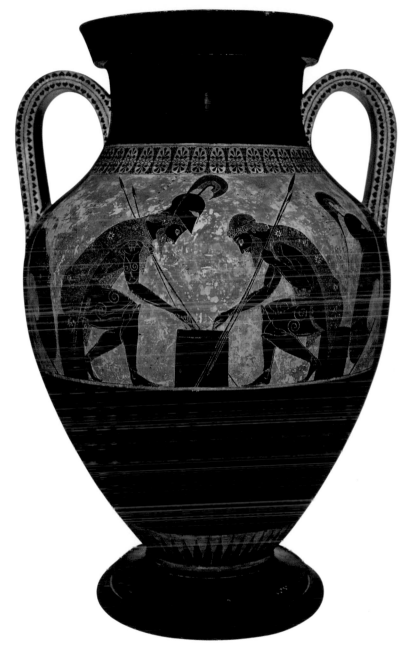

Figure 29. Exekias

Achilles and Ajax playing a board game. The names of Ajax and Achilles are inscribed, and they call out the numbers on the dice, three (*tria*) and four (*tes[s]era*), which are inscribed as if issuing from their mouths. A KALOS INSCRIPTION is on the right, and Exekias's SIGNATURE (as potter) is on the left. If this scene was invented by Exekias, as some scholars believe, it must have been the prototype for the scene on figure 59. Black-figured AMPHORA (Type A) signed by Exekias as potter and painter, about 530–520. H: 61 cm (24 in.). Vatican, Museo Gregoriano Etrusco 16757.

FIGURE 30.
GROUP E
Hoplites (foot
soldiers) and cavalry.
Note drill holes at the
shoulder edge of the
vase indicating ancient
REPAIRS. Black-figured
neck-AMPHORA
attributed to the
Painter of London
B 174, one of the
painters of Group E,
about 540. H: 36.2
cm (14¼ in.). Malibu,
JPGM 86.AE.73.

GROUP E (active mid-sixth century B.C.)

BEAZLEY called Group E (the E stands for EXEKIAS) "the soil from which the art of Exekias springs." This GROUP of black-figure painters produced many types of vases, with a preference for AMPHORAE. Their images depict primarily battles and episodes from the adventures of gods and heroes. Their figural style is monumental, solid, and black, with female skin often painted in ADDED WHITE and important details in ADDED RED. FIGURE 30

KLEITIAS (active around 570–560 B.C.)

A master of early BLACK-FIGURE painting, Kleitias was a miniaturist whose figures are remarkable for their INCISED and painted details. His most elaborate work is the François Vase (named after the man who found it in an Etruscan tomb), which is the earliest known Athenian volute-KRATER. FIGURE 31

KLEOPHON PAINTER (active approximately 440s–420s B.C.)

An artist of the GROUP of POLYGNOTOS and a contemporary of the ERETRIA PAINTER, the Kleophon Painter worked during the later phase of the building of the Parthenon (constructed 447–432 B.C.) and into the early years of the Peloponnesian War (431–404 B.C.). The Classical style epitomized by the Parthenon sculptures evidently influenced the Kleophon Painter's treatment of garments and figural compositions. Like Polygnotos, he decorated large

FIGURE 31.**KLEITIAS**
The François Vase. With multiple narrative friezes containing 121 INSCRIPTIONS naming most of the
characters, including Peleus and Thetis, whose wedding is the principal scene depicted, this vase is the
most heavily inscribed Greek vase known. Black-figured volute-KRATER signed by Ergotimos as potter
and Kleitias as painter, about 570. H: 66 cm (26 in.). Florence, Museo Archeologico 4209.
Photo Nimatallah/Art Resource, New York.

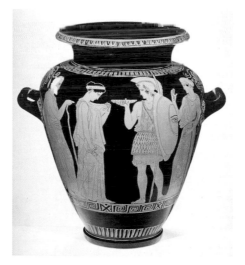

FIGURE 32.
KLEOPHON PAINTER
Departure scene:
Warrior holding a
ceremonial PHIALE,
which has been filled
with wine from the
OINOCHOE held by
his wife. Red-figured
STAMNOS attributed
to the Kleophon
Painter, about 430.
H: 43.5 cm (17⅛ in.).
Munich, Staatliche
Antikensammlungen
und Glyptothek
2415 WAF.

vases, on which he typically depicted aspects of Athenian daily life. The Kleophon Painter is named after a KALOS INSCRIPTION (*Kleophon kalos*) on a STAMNOS in St. Petersburg. FIGURE 32

KLEOPHRADES PAINTER (active approximately 500–470 B.C.)

A pupil of EUTHYMIDES and certainly one of the most talented red-figure vase-painters, the Kleophrades Painter was a contemporary of the BERLIN PAINTER. The word that perhaps best describes the Kleophrades Painter's style is "grandeur," what the ancient Greeks called *megethos*. Also translated as "largeness of spirit," the word denotes a certain seriousness of manner, an element present already in black-figure painting, notably that of LYDOS and EXEKIAS. The Kleophrades Painter's most famous picture, on a KALPIS, depicts a number of separate events that took place during the Sack of Troy. These events are illustrated in a single panel that runs continuously around the shoulder of the vase instead of being framed into one or more panels. This pictorial format—which was new—and the monumentality of the style suggest the possible appearance of lost ancient wall-paintings.

In black-figure the Kleophrades Painter produced a number of PANA-THENAIC AMPHORAE, readily recognizable by his exclusive use of Pegasos to

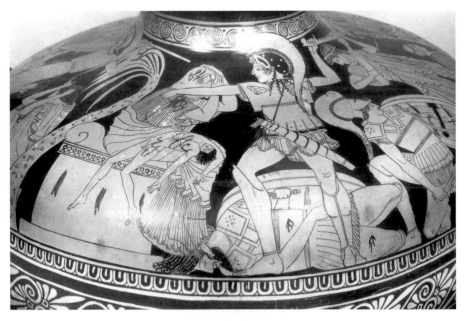

FIGURE 33. **KLEOPHRADES PAINTER**
Death of Priam. Detail of shoulder of a red-figured HYDRIA (kalpis) attributed to the Kleophrades Painter, about 490. Naples, Museo Nazionale Archeologico H2422.

decorate Athena's shield. His use of INCISIONS for OUTLINES in his black-figure work rather than RELIEF LINES is probably an archaism inherited from his early training in black-figure. He is named after the potter signature *Kleophrades* on one of his cups, which is now in the Cabinet des Médailles in Paris. FIGURES 33, 77, 113.1, 113.4, 131

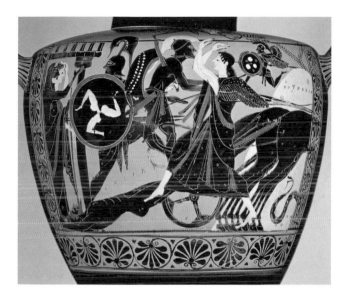

LEAGROS GROUP (active 520–500 B.C.)

This large and productive GROUP comprises the best of the late sixth-century-B.C. black-figure vase-painters and is contemporary with the red-figure PIONEERS. Their drawing style and their fondness for epic subject matter continue the monumental style of LYDOS and EXEKIAS. They liked to write INSCRIPTIONS on their vases, although they may be nonsense rather than real words. Battle scenes are among their favorite subjects, and some of their best efforts illustrate the Trojan War, such as the Dragging of Hektor's Body around the walls of the citadel (see fig. 34). The HYDRIA was their favorite shape; a typical composition will feature teams of horses exiting or bounding in from the sides of the panel framing the central scene. BEAZLEY named the Group from KALOS INSCRIPTIONS on five hydriai by five different but stylistically related painters. FIGURES 34, 59, 76

FIGURE 35.
LITTLE MASTER
Black-figured LITTLE-MASTER lip-CUP attributed to the WORKSHOP of the Phrynos Painter, about 550. Nonsense INSCRIPTIONS in the handle zones are intended to mimic actual artists' SIGNATURES. H: 15 cm (5⅞ in.). Malibu, JPGM, Gift of Barbara and Lawrence Fleischman, 96.AE.91.

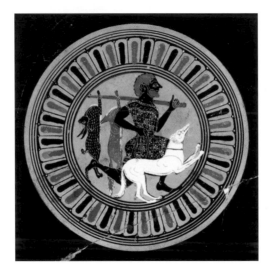

FIGURE 36.
LITTLE MASTER
TONDO of a black-figured Little-Master lip-CUP signed by Tleson, and perhaps painted by the Tleson Painter, about 540. London, BM B 421. © BM.

LITTLE MASTERS (active 560–530 B.C.)

Descriptive name applied to black-figure miniaturist painters of so-called Little-Master CUPS (lip-cups, band-cups, Droop cups). (See KYLIX for the origin of the term Little Master.) Frequently their subjects were animals, centrally placed between the handles and/or on the lip of the cup. Often the artist's SIGNATURE was an important part of the decoration. Among the best Little Masters were the Phrynos Painter and the Tleson Painter, but many others, including the AMASIS PAINTER, worked on Little-Master cups. FIGURES 35, 36

LYDOS (active 560–540 B.C.)

A black-figure painter of great imagination as well as conceptual and techni-
cal ability. On two vases he signed as *ho Lydos*, the Lydian, indicating that
he or his family had immigrated to Athens from Lydia in Asia Minor (mod-
ern Turkey). His sturdy figures have a distinctive monumentality that im-
parts dignity rather than mere bulk. Among the new subjects Lydos proba-
bly introduced to Athenian vase-painting are Theseus and the Minotaur, and
Herakles fighting the triple-bodied Geryon. Lydos preferred to work on large
shapes, especially KRATERS and AMPHORAE, though he also painted smaller
shapes such as CUPS. FIGURES 37, 113.5

LYSIPPIDES PAINTER (active 530–515 B.C.)

Named by BEAZLEY after a KALOS INSCRIPTION on a neck-AMPHORA now in London. He was the painter of many of the black-figured sides of BILINGUAL AMPHORAE, for which the ANDOKIDES PAINTER completed the red-figured decoration. The bilingual format necessitated such a close collaboration that the two painters (neither of whom signed his name on any of his works) may in fact have been one person, painting in both techniques. FIGURES 20–21, 65, 72, 87, 127

MAKRON (active approximately 490–475 B.C.)

With DOURIS, ONESIMOS, and the BRYGOS PAINTER, Makron was one of the most important red-figure CUP-painters of the Late Archaic period (530–480 B.C.). He must have been one of the most prolific of all red-figure painters, for more than six hundred vases are ATTRIBUTED to his hand. He seems to have worked exclusively with the potter Hieron, mostly decorating KYLIKES and SKYPHOI. One of Makron's most characteristic works is a kylix in Berlin, signed by Hieron as potter, depicting the ecstatic worship of Dionysos: maenads sway and twirl, the folds of their garments following their every movement; this ebullient treatment is a hallmark of Makron's style. FIGURES 38, 58

FIGURE 38. **MAKRON**
Worship of Dionysos. Detail of red-figured KYLIX (Type B) signed by Hieron as potter and attributed to Makron as painter, about 490. Diam. 33 cm (13 in.). (Staatliche Museen zu Berlin—Preußischer Kulturbesitz, Antikensammlung F 2290. Photo Ingrid Geske.

MANNERIST

Descriptive title—adopted from terminology applied to sixteenth-century Italian painters—for certain black-figure and red-figure artists with highly idiosyncratic drawing styles. BEAZLEY tellingly named two black-figure Mannerists the "Affecter" and "Elbows Out" after their self-conscious, "mannered" styles characterized by unnatural, excited gestures and oddly proportioned physiques. Both were active during the third quarter of the sixth century. The red-figure Mannerists, who worked during the Early Classical period (480–450 B.C.), had less extreme idiosyncrasies; the PAN PAINTER was the most talented of them. The Mannerists of both techniques decorated mostly larger shapes, such as AMPHORAE, column-KRATERS, PELIKAI, and HYDRIAI. FIGURES 39, 47

MARSYAS PAINTER (active approximately 370–335 B.C.)

The principal painter of KERCH-STYLE vases, the Marsyas Painter was the most important artist working in the KERAMEIKOS in the fourth century. He is named after his depiction of Apollo and the satyr Marsyas on a PELIKE in St. Petersburg. Although he normally worked in red-figure, the Marsyas Painter, like the KLEOPHRADES PAINTER, also decorated black-figured

PANATHENAIC AMPHORAE, a testimony to the continued ability of painters to work in both techniques with considerable skill. On a pelike in London the ADDED WHITE used for the flesh tones of Thetis is a prime example of a drawing of the female nude that undoubtedly was influenced by contemporary monumental sculpture. FIGURE 40

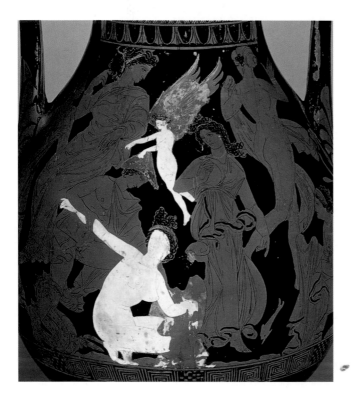

FIGURE 40.
MARSYAS PAINTER
Peleus and Thetis.
Detail of KERCH-
STYLE PELIKE
attributed to the
Marsyas Painter,
about 370–335.
London, BM E 424.
© BM.

MEIDIAS PAINTER (active last quarter of the fifth century B.C.)

In the tradition of the ERETRIA PAINTER, the Meidias Painter depicted the Athenian women's world as a feminine paradise. The best vase-painter of the Late Classical period (425–300 B.C.), the Meidias Painter used a luxurious treatment even for violent and warlike scenes, giving them a softness that at times belies their technical strength. He painted on both large and small vases, but the HYDRIA was his favorite shape; he often set up several registers of figures with sultry gazes and erotically charged costumes enhanced with applied GILDING. His style greatly influenced painters of his day and later (see fig. 7), as is evident, for instance, in the grander compositions of the DINOS PAINTER (see fig. 25). The Meidias Painter's name derives from a potter SIGNATURE on a hydria in London. FIGURES 41, 42, 114

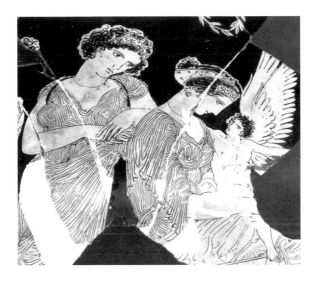

FIGURE 41.
MEIDIAS PAINTER
Helen among her sisters. Detail of red-figured HYDRIA (kalpis) attributed to the Meidias Painter, about 420. Athens, Kerameikos Museum 2712. © DAI Athens, neg. no. KER 7094.

FIGURE 42. **MEIDIAS PAINTER**
In the upper zone, the Dioskouroi Stealing the Daughters of Leukippos; in the lower zone, Herakles in the Garden of the Hesperides. Red-figured HYDRIA (kalpis) signed by Meidias as potter and attributed to the Meidias Painter (NAME VASE), about 420. Part of the founding collection of Greek vases at the British Museum in 1772, this vase had been the jewel of Sir William Hamilton's collection (see p. 3). H: 52.1 cm (20½ in.). London, BM E 224. © BM.

NIKOSTHENES (active approximately 550–510 B.C.)

A potter who owned a WORKSHOP in Athens, Nikosthenes signed his name to more black-figured vases than any other artist; his production overlapped with the beginning stages of red-figure, and his younger partner may have been Pamphaios, who subsequently seems to have taken over his workshop. Nikosthenes apparently specialized in producing vases for the export market, of which the best example is a neck-AMPHORA of special shape, the so-called "Nikosthenic amphora." The shape—derived from an Etruscan vase form and unknown in mainland Greece—was a very popular export to Etruria. See also AMPHORA. FIGURES 43, 88

NIOBID PAINTER (active approximately 470–450 B.C.)

The Niobid Painter and his GROUP differ from earlier red-figure painters in that their attention is focused not solely on the human figure but also on the effort to represent figures in three-dimensional space—an innovation inspired by the multi-level compositions of contemporary wall- and panel-paintings. On his NAME VASE, a calyx-KRATER (see fig. 44), the painter depicts the slaughter of the children of Niobe by Apollo and Artemis, the children of Leto. The Niobids flee and fall in a rocky landscape, which the painter has constructed on a number of different levels. Most unusual is the single arrow in the lower right corner of the painting. Since Apollo's arrows never miss

their mark, this arrow must be understood as emerging from the body of an unseen Niobid behind the mound. The implied presence of a body that is not actually represented is a remarkable development that places the work of the Niobid Painter in a new era. However, such sophisticated multilevel compositions never became popular, and most of the Niobid Painter's pictures are on a single groundline. His fondness for Amazon battles and three-quarter-view faces was continued by POLYGNOTOS. FIGURES 44, 45

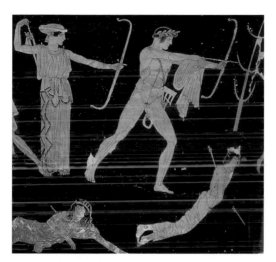

FIGURE 44.
NIOBID PAINTER
Death of the Niobids.
Detail of red-figured
calyx-KRATER
attributed to the
Niobid Painter
(NAME VASE), about
470–450. Paris,
Musée du Louvre
G 341. © RMN–H.
Lewandowski.

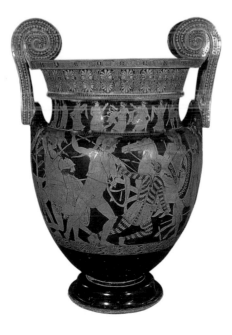

FIGURE 45.
NIOBID PAINTER
Amazonomachy
(Amazon battle). Red
figured volute-KRATER
attributed to the
Niobid Painter, about
460. H: 79.8 cm
(31⅜ in.). Naples,
Museo Nazionale
Archeologico H2421.

OLTOS (active approximately 525–500 B.C.)

Oltos began his career as a BILINGUAL artist but became perhaps the most influential red-figure CUP-painter of the first generation following the PIONEERS. He is credited with more bilingual EYE-CUPS than any other painter, but he painted larger shapes as well, working for many different potters, including NIKOSTHENES. His narrative arrangements, which often link the iconography of a cup's TONDO to the scenes on its exterior, are particularly innovative and presage the work of later cup-painters such as the BRYGOS PAINTER. FIGURE 46

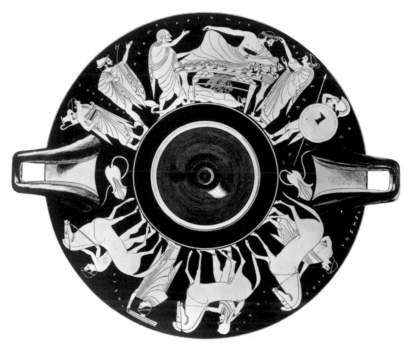

FIGURE 46. **OLTOS**
The Ransom of Hektor. Exterior of red-figured KYLIX attributed to Oltos, about 520–510.
Diam: 32 cm (12⅝ in.). Munich, Staatliche Antikensammlungen und Glyptothek 2618. Drawing by
Karl Reichhold (see p. 4). From Furtwängler and Reichhold, *Griechische Vasenmalerei*,
vol. 2, pl. 83. Photo Library Getty Research Institute.

ONESIMOS (active approximately 510–485 B.C.)

Onesimos was primarily a painter of red-figured CUPS; at the height of his career he was, perhaps, the most skilled vase-painter in Athens. He apprenticed with the PIONEERS, working especially with his teacher, EUPHRONIOS, both when they painted together as master and pupil and later when the elder Euphronios potted for the younger man's painting. Onesimos's pictures are

painstakingly arranged to harmonize with the shape of the vase; he approached the representation of his subjects with comparable ingenuity. He favored scenes of daily life and treated myth only rarely but then exceptionally, often (like OLTOS) organizing an entire vase around one particular theme, such as the Deeds of Theseus or the Sack of Troy. FIGURES 6, 16

PAN PAINTER (active approximately 480–450 B.C.)

The best of the MANNERIST painters, the Pan Painter gets his name from a bell-KRATER that shows, on one side, Pan chasing a goatherd, and, on the other side, the Death of Aktaion, torn to shreds by his dogs as punishment for having watched Artemis bathing. Among his Mannerist traits are the precious little dogs who leap and snap as well as the patterned garments and twisted poses of the characters. FIGURE 47

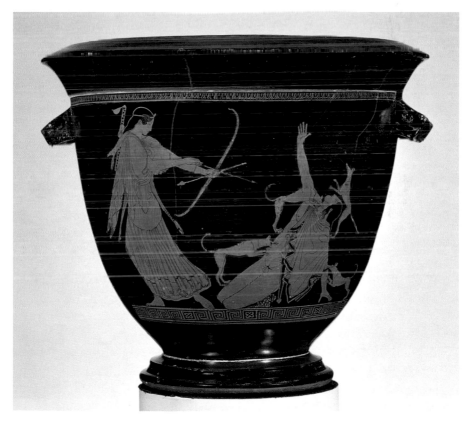

FIGURE 47. **PAN PAINTER**
Death of Aktaion. Red-figured bell-KRATER (with lug-handles) attributed to the Pan Painter
(NAME VASE), about 470. H: 37 cm (14⅝ in.). Boston, MFA, James Fund and by
Special Contribution, 10.185. Courtesy, MFA, Boston. Reproduced with permission.
© 2000 MFA, Boston. All rights reserved.

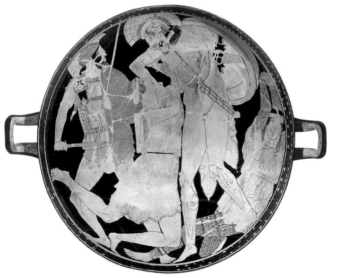

FIGURE 48.
PENTHESILEA PAINTER
Greeks battling
Amazons during the
Trojan War, with
Achilles and
Penthesilea in the
center. Interior of
red-figured KYLIX
(Type C) attributed to
the Penthesilea Painter
(NAME VASE), about
460–440. Diam:
43 cm (16⅞ in.).
Munich, Staatliche
Antikensammlungen
und Glyptothek 2688.

PENTHESILEA PAINTER (active approximately 460–440 B.C.)

A pupil of the PISTOXENOS PAINTER, the Penthesilea Painter was the principal painter of the largest WORKSHOP in Athens specializing in CUPS. Stylistic analysis of the individual hands at work in the Penthesilean workshop has shown that two painters often collaborated on the decoration of a cup, one painting the exterior and another (usually the better of the two) decorating the TONDO. In the interior of his NAME VASE in Munich (see fig. 48) the painter has filled the entire space with the fight between Achilles and the Amazon queen Penthesilea (flanked by another Greek and a dead Amazon), no doubt influenced by monumental wall-paintings of the same subject that were well known in contemporary Athens. Despite this apparent debt to wall-painting and the picture's grand format, the figures' poses were still made to conform to the tradition of tondo painting. The Penthesilea Painter was an accomplished painter of WHITE-GROUND as well (see fig. 128). FIGURES 48, 128

PHIALE PAINTER (active 450–430 B.C.)

A pupil of the ACHILLES PAINTER, called by BEAZLEY "an artist of true charm" and "nobility." With notable technical breadth, the Phiale Painter worked in red-figure on a wide variety of shapes and in WHITE-GROUND on several funerary LEKYTHOI. He is known also for his spacious compositions on white-ground calyx-KRATERS, where the white background and generous POLYCHROMY likely approximate the appearance of now-lost wall- and panel-paintings. His choice of subject, on the other hand, does not appear to

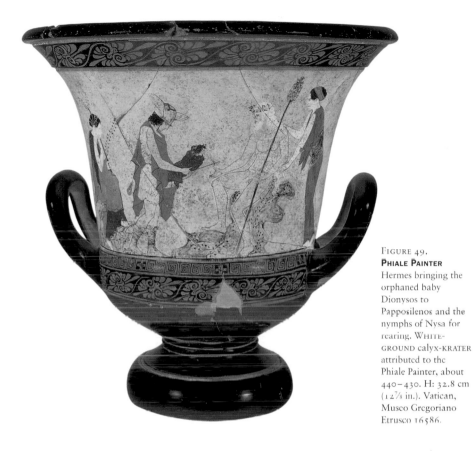

FIGURE 49.
PHIALE PAINTER
Hermes bringing the
orphaned baby
Dionysos to
Papposilenos and the
nymphs of Nysa for
rearing. WHITE-
GROUND calyx-KRATER
attributed to the
Phiale Painter, about
440–430. H: 32.8 cm
(12⅞ in.). Vatican,
Museo Gregoriano
Etrusco 16586.

derive from monumental models (as seems to have been the case for his con-
temporaries POLYGNOTOS and the KLEOPHON PAINTER) but displays a per-
sonal interest in the theater. One scene, the subject of a contemporary play
by Sophokles, shows Hermes bringing the infant Dionysos to the nymphs of
Nysa (see fig. 49). The painter is named after a PHIALE in Boston (see figs.
118–19). FIGURES 49, 118–19

PIONEERS (active around 525–500 B.C.)

A GROUP of red-figure vase-painters were given this name by BEAZLEY be-
cause, while not the inventors of red-figure (see ANDOKIDES PAINTER, PSIAX),
they were the first to explore what the new technique had to offer and to
establish the direction it would take. Experiments in drawing the human
body, including foreshortening, characterize their work. This same spirit of
experimentation is responsible for the development of complex narrative
scenes populated by figures in active poses. Chief among the Pioneers were
EUPHRONIOS, EUTHYMIDES, and Phintias. FIGURES 1, 3, 9, 17, 101, 110

FIGURE 50. **PISTOXENOS PAINTER**
Aphrodite riding on a goose. Interior of WHITE-GROUND KYLIX (Type C) attributed to the Pistoxenos
Painter, about 470–460. The drawing is made entirely with DILUTE GLOSS, with POLYCHROMY of
purple-red for Aphrodite's cloak and white for the MEANDER on the edge. Diam: 24 cm (9½ in.).
London, BM D 2. © BM.

PISTOXENOS PAINTER (active approximately 475–460 B.C.)

One of the first Early Classical CUP-painters, whose work, especially in the
TONDI of WHITE-GROUND cups, is characterized by its graceful style. One of
the most telling details of Classical style is the depiction of the eye in profile
view, first fully realized in the work of the Pistoxenos Painter and his fellow
artist the PENTHESILEA PAINTER. Lines that earlier had been painted in GLOSS
with a certain hardness are now replaced by the use of the softer DILUTE
GLOSS accentuated by POLYCHROMY. This is beautifully demonstrated in the
Pistoxenos Painter's image of Aphrodite gliding through the air on her goose,
holding in her hand a flowering ornament. The Pistoxenos Painter is named
after a potter SIGNATURE on a SKYPHOS in Schwerin. FIGURE 50

POLYGNOTOS (active 450–420s B.C.)

Polygnotos was the central figure in a large and active GROUP of painters who
worked during the high Classical period. Like the NIOBID PAINTER, in whose
WORKSHOP he was trained, Polygnotos imbued his pictures with monumen-

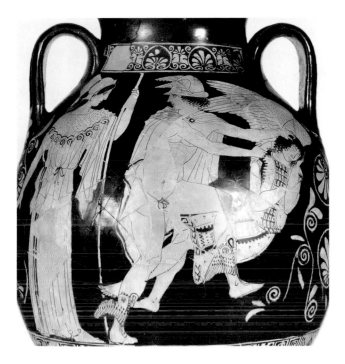

tality, in particular in his battle scenes (especially those with Amazons). At
the height of his career, during the 430s, Polygnotos produced works that
reflect the direct influence of the recently completed Parthenon sculptures:
Galloping riders on a STAMNOS seem to have leapt directly off Pheidias's
marble frieze; and a battle with a Centaur recalls the composition of the
metopes on the temple. The calm dignity of the Pheidian style in general is re-
flected even in Polygnotos's mythological paintings, such as the beheading of
Medusa by Perseus (see fig. 51), which Archaic painters would have treated
in a much more animated fashion. FIGURE 51

PRONOMOS PAINTER (active at the end of the fifth century B.C.)
The Pronomos Painter took the sturdy figural style he learned from his mas-
ter, the DINOS PAINTER, and embellished it with a profusion of ORNAMENT,
POLYCHROMY, and GILDING. He is named after the figure of a flute-player on
a volute-KRATER in Naples, which depicts on SIDE A the company of a satyr
play (see fig. 52). Dionysos and Ariadne appear as patrons of the dramatic
arts in the center of the upper register, surrounded by the actors and chorus.
Among others below identified by INSCRIPTION are Demetrios, who may have
been the playwright, and Pronomos (see fig. 53), the flute-player, who is
known from ancient literature as a musician and composer. FIGURES 52–53

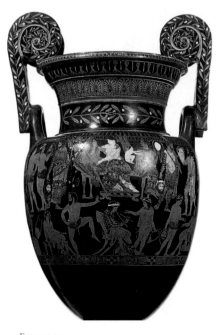

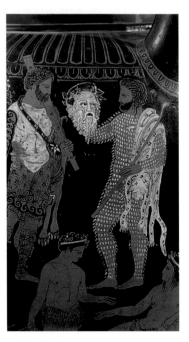

PSIAX (active approximately 530–515 B.C.)

A BILINGUAL painter, Psiax was the leader of a large WORKSHOP and a col-
league of the LYSIPPIDES and ANDOKIDES PAINTERS during the final phase of
black-figure technique. Psiax's black-figured work shows attention to small de-
tails in the tradition of the AMASIS PAINTER (who may have been his teacher).
In his red-figured compositions and figural work Psiax is inventive, and he
seems to have been one of the first to use the new technique. FIGURES 54, 109

SOPHILOS (active 580s–570 B.C.)

Sophilos is the earliest ATTIC vase-painter whose proper ancient name we
know. In his style and interest in narrative subjects he was a precursor of the
C PAINTER, whose early career overlapped with Sophilos's later work. A pre-
served fragment of a DINOS by Sophilos depicts a famous but rarely repre-
sented subject: the Funeral Games for Patroklos (see fig. 55), which are
described by Homer at the end of the *Iliad*. In a unique outdoor scene, a

FIGURE 54.
PSIAX
Herakles and Athena,
with chariot. Between
the legs of the horses is
a KALOS INSCRIPTION,
Hipokrates kalos
(Hippokrates is
beautiful). Detail of
black-figured side of a
BILINGUAL AMPHORA
(Type A) attributed to
Psiax, about 530–515.
Munich, Staatliche
Antikensammlungen
und Glyptothek 2302.

FIGURE 55. **SOPHILOS**
The Funeral Games for Patroklos (according to one of the INSCRIPTIONS).
Fragment of a black-figured DINOS signed by Sophilos as both potter and painter, about 580–570.
Athens, National Museum 15499. © DAI Athens, neg. no. NM 4151.

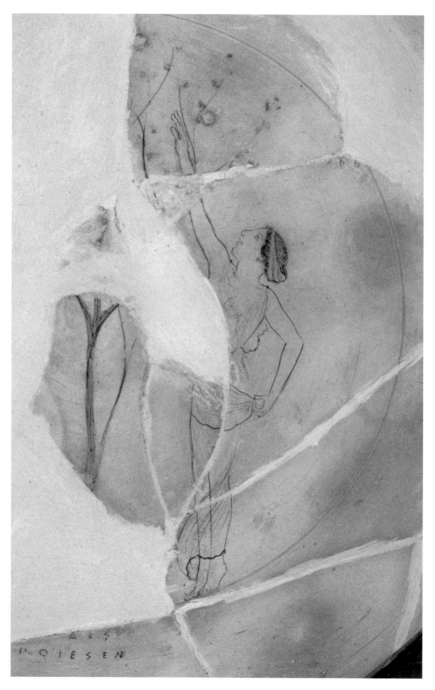

FIGURE 56. **SOTADES**
Nymph picking apples in the Garden of the Hesperides. Detail of a WHITE-GROUND KYLIX (Type C)
signed by Sotades as potter just below the picture and attributed to the Sotades Painter,
about 460–450. London, BM D 6. © BM.

grandstand is filled with wildly gesticulating people watching a chariot race of which only the horses of one chariot remain. Sophilos signed this piece twice, writing "Sophilos painted [me]" to the right of the horses' heads; above their backs only two letters are preserved of what was probably his signature as potter, "Sophilos made [me]." Two further inscriptions identify the picture: "[the] games [in honor of] Patroklos," written immediately to the left of the grandstand; "Achilles," to the right, names the hero and great friend of Patroklos. FIGURE 55

SOTADES/SOTADES PAINTER (active mid-fifth century B.C.)

Sotades was a potter who specialized in PLASTIC VASES, some of which were decorated by an artist who is named the Sotades Painter after him. The painter's work is found on a wide variety of rare shapes, including an ASTRAGALOS showing a man leading a group of dancing women (see fig. 64). He also painted a unique set of WHITE-GROUND CUPS commissioned especially for placement in a tomb. The diaphanously clothed nymph reaching for an apple has been interpreted as a Hesperid (see fig. 56), a guardian of the Golden Apples of the Hesperides, which conferred immortality on those (such as Herakles) who picked them. The painter used particularly fine OUTLINE DRAWING to describe remarkably fluid actions. Although the extensive POLYCHROMY has faded with age, a good sense can still be had of the originally vibrant condition. FIGURES 56, 64, 121

M. I. H.

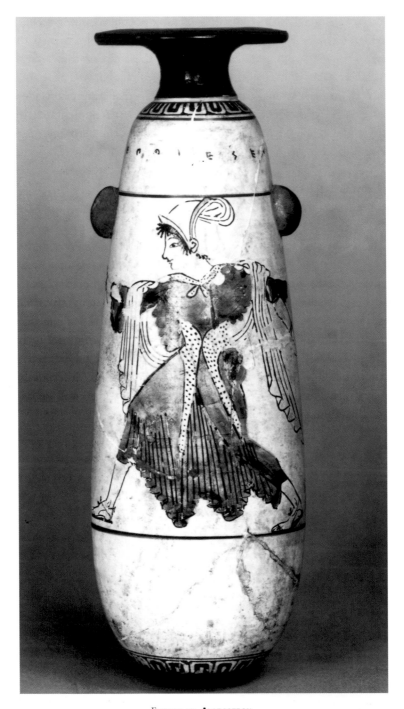

FIGURE 57. **ALABASTRON**
Maenad. WHITE-GROUND alabastron signed by Pasiades as potter and attributed to the Pasiades
Painter, about 500. H: 14.6 cm (5¾ in.). London, BM B 668. © BM.

Glossary of Vase Shapes and Technical Terms

ADDED COLORS See COLOR.

ALABASTRON (pl. ALABASTRA)

Bottle for plain or scented oil (perfume). The shape originated in Egypt, where it was made in glass, faience, or alabaster—the stone from which the shape takes its name (Gr. ἀλάβαστρον, alabaster). This slender, elongated vase is small enough to be held in one hand; alternatively, it could be carried by a string looped around its narrow neck or passed through small lugs on the shoulder. Most alabastra have rounded bottoms, but footed examples are known, too. Vase-paintings show women using alabastra in a domestic context. Like LEKYTHOI, alabastra were left as offerings at tombs. FIGURE 57

ALIEN (OR FOREIGN)

A fragment or section joined to a broken vase it does not actually belong to is said to be alien. In antiquity alien fragments were occasionally used to repair broken vases. See also REPAIRS. FIGURE 58

FIGURE 58. **ALIEN**
The intrusion of marine motifs into this figural scene indicates that an alien fragment (from a KYLIX painted by MAKRON) has been used to REPAIR this cup in ancient times. In this rare example, the corroded metal pins are still in place. Detail of the exterior of a red-figured KYLIX signed by DOURIS as painter, about 480 (see also fig. 102). Malibu, JPGM 84.AE.569. Photo Penelope Potter.

AMPHORA (pl. AMPHORAE or AMPHORAS)

One of the most common ATTIC shapes. The ancient name—*amphora* in Latin, *amphoreus* (ἀμφορεύς) in Greek—is derived from the shape's two vertical handles (Gr. ἀμφί, on both sides, and φέρω, to carry). Amphorae were general-purpose containers that could hold liquid (honey, milk, oil, wine, or water), dry goods, or small foods (olives). They were used also as receptacles for the ashes of the deceased. Amphorae often had lids, but very few survive.

The two basic forms are amphora and neck-amphora. The earlier is the *neck-amphora*, whose neck joins the shoulder at a sharp angle (see figs. 30, 59, 90, 124, 138). The other form, usually simply called *amphora* (or *one-piece amphora* or *belly-amphora*), is continuously curved from neck to foot (figs. 19, 20–21, 22, 29). The two forms differ also by their overall color and the format of their pictures. The black-figured neck-amphora, an especially popular shape, is a "light" vase: Neck and body are RESERVED, and the pictures are not in panels. The black-figured and red-figured amphorae and the red-figured neck-amphora are "dark": predominantly black, the pictures on the black-figured amphora are enclosed within windowlike panels, while pictures on the red-figured forms are only sometimes in panels.

There are three principal variations of the amphora, *Types A, B,* and *C.* *A* has a flaring mouth, flanged handles with reserved sides usually decorated with an ivy design, and a foot in two degrees, or, steps (see fig. 29). *B*, the oldest and most common form, has round black handles and an echinus foot (shaped like an upside-down shallow bowl; see fig. 19). *C*, of which there are relatively few examples, differs from B by its torus (tire-shaped, see fig. 22) mouth and its foot, either a torus or an echinus. The PANATHENAIC AMPHORA (see fig. 117) is a famous variant of the neck-amphora.

The singular shape of the *Nikosthenic neck-amphora* (see fig. 43), known mainly in black-figure, was adapted by the potter NIKOSTHENES from a native Etruscan shape; many of these amphorae bear his SIGNATURE, and it is thought that the vases were produced especially for the Etruscan market. The *Nolan amphora* (named after Nola, in South Italy), a small type of neck-amphora confined to red-figure, is predominantly black and has ridged handles; a Nolan with double handles (each composed of two cylindrical sections) is called a *doubleen*. A *pointed amphora* has a pointed or knob-foot and requires a stand; in its unpainted form this was the standard container for commercial transportation of wine and oil. An *amphoriskos* (Gr. ἀμφορίσκος, pl. *amphoriskoi*) is a very small pointed neck-amphora used for scented oil (perfume). FIGURES 1, 5, 19, 20–21, 22, 29, 30, 37, 39, 43, 54, 59, 79, 85, 90, 117, 124, 126, 138

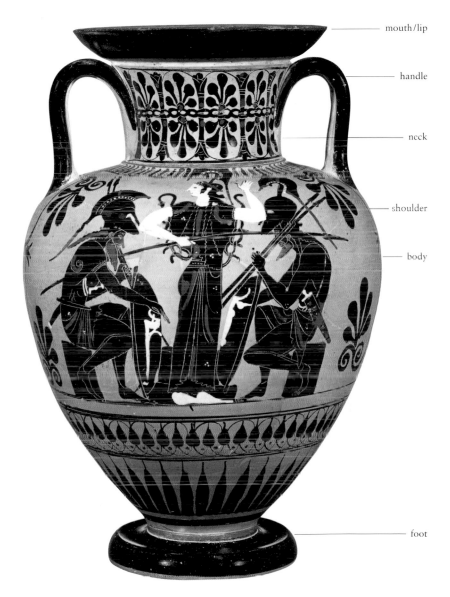

mouth/lip

handle

neck

shoulder

body

foot

FIGURE 59. **AMPHORA**
Achilles and Ajax playing a board game, with Athena standing between them. Diagram of a typical
black-figured neck-AMPHORA, showing the principal parts of an Athenian vase: mouth, neck,
handles, shoulder, body, foot (cf. p. 4). Attributed to a painter of the LEAGROS GROUP, about 510.
H: 45.3–45.8 cm (17⅞–18 in.). Malibu, JPGM 86.AE.81.

ANIMAL STYLE

The use of animals as the predominant decorative motifs on painted pottery. The term is most often associated with pottery from CORINTH and EAST GREECE, where the style (based on ORIENTALIZING motifs) was especially popular. The animals are both real (felines, birds, bulls, boars, goats, deer, dogs, and hares) and imaginary (sirens, sphinxes, and griffins). FIGURES 60, 75

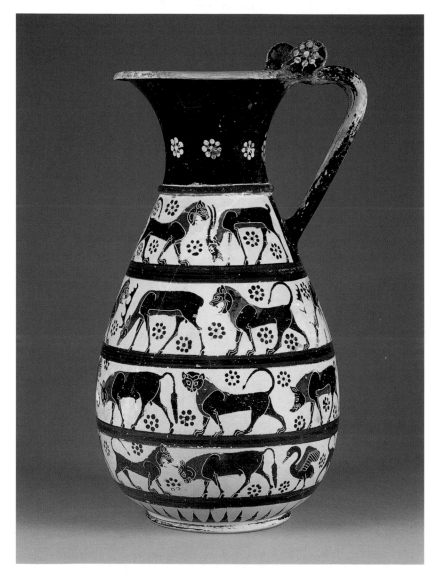

FIGURE 60. **ANIMAL STYLE**
Friezes decorated in Animal Style. PROTOCORINTHIAN OLPE attributed to the Painter of Malibu 85.AE.89 (NAME VASE), about 650–625. H (to rim): 30.6 cm (12 in.). Malibu, JPGM 85.AE.89.

ARTISTS' NAMES

Sometimes potters or painters signed their vases (see SIGNATURES), although mostly they did not. Even those who repeatedly signed their works did not sign all of them. The names invented by BEAZLEY and many other scholars for painters who did *not* sign have various origins. For example: the AMASIS PAINTER, originally named for (then identified by some with) the potter Amasis (who signed some of the vases he potted); the BERLIN PAINTER, named for the city of Berlin, where one of his best vases is in the Antikensammlung; the Carpenter Painter, named for the subject of a picture; or the Affecter, named for the peculiar, or affected, proportions and gestures of his figures. When an artist's name derives from a particular vase, that vase is said to be his *name vase*. For other types of names, see CLASS and GROUP.

ARYBALLOS (pl. ARYBALLOI)

Small bottle for plain and, perhaps, scented oil (perfume). The name is ancient, but aryballos (Gr. ἀρύβαλλος) could not have been the name only for this shape, since it was applied in antiquity also to LEKYTHOI and other vases. The round-bodied aryballos originated in CORINTH (see fig. 71), and few ATTIC examples of this particular type are known. Representations on vases and in sculpture show athletes (men and boys) holding an aryballos in one hand, dispensing oil onto their skin, or carrying the vase suspended from the wrist by a string looped around its narrow neck. Footed aryballoi are rare. Besides round aryballoi, which were wheelmade, there were moldmade plastic aryballoi (see PLASTIC VASES); such aryballoi in the shape of an owl (the goddess Athena's bird) or of three conjoined cockleshells were popular forms. FIGURES 61, 71

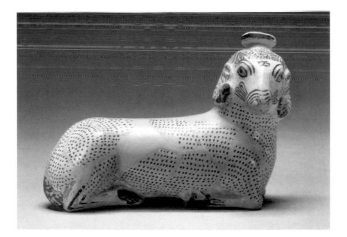

FIGURE 61.
ARYBALLOS
CORINTHIAN aryballos in the shape of a ram, about 640–625. L: 14 cm (5½ in.). Malibu, JPGM 86.AE.696.

Askos (pl. ASKOI)

Small container named for its vague resemblance to a wineskin (Gr. ἀσκός); however, *askos* is in all likelihood not the ancient name of the shape. The askos is a red-figure shape; in its most characteristic form it is a very low, round-bodied vase—convex top, flat bottom—with a mouth and handle on the topside; in its rarer, relatively taller form the body is tubular. The small size and narrow neck suggest that the askos was a vase designed for carefully pouring liquids such as plain or scented oil (perfume), honey, or vinegar. Although very likely used for libations in funerary rituals, the vase probably had other functions too. Askoi with MOLDED bodies (see PLASTIC VASES) had zoomorphic shapes such as ducks or lobster claws. FIGURES 62–63

FIGURES 62–63.
ASKOS
Boar and lion.
Red-figured askos,
about 410. H: 6.7 cm
(2⅝ in.). Malibu,
JPGM 83.AE.396.

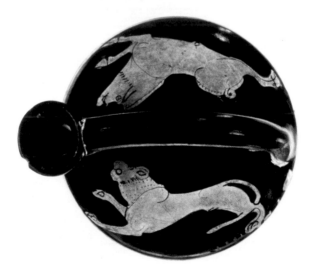

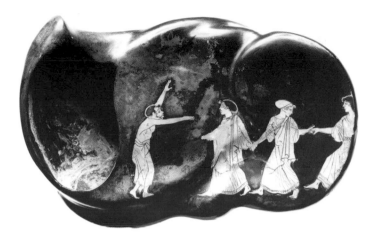

FIGURE 64.
ASTRAGALOS
Dancing figures. Red-
figured astragalos
attributed to the
SOTADES PAINTER,
about 500–450.
H: about 12 cm
(4¾ in.). London,
BM E 804. © BM.

ASTRAGALOS (pl. ASTRAGALOI)

Rare red-figured vase in the shape of a knucklebone (Gr. ἀστράγαλος). Its an-
cient name is unknown, but it seems sensible that it was called *astragalos*. The
Greeks and Romans used sheep knucklebones (the metacarpal or metatarsal
bones) as gaming pieces, or dice, and it has been suggested that the astraga-
los vase may originally have been used as a container for them. FIGURE 64

ATTIC/ATTICA

Of or related to Attica, the region of which Athens is the capital. In vase ter-
minology *Athenian* is often used as a synonym for *Attic*.

ATTRIBUTION Ascribing unsigned vases to artists. See BEAZLEY, ARTISTS' NAMES.

BEAZLEY, SIR JOHN D.

Lincoln Professor of Classical Archaeology and Art in the University of Ox-
ford 1925–1956, Sir John D. Beazley (1885–1970) undertook the enormous
task of identifying the individual styles of ATTIC vase-painters and in so do-
ing established the entire development of Attic vase-painting. Adapting meth-
ods that had been used to distinguish Italian Renaissance painters, Beazley
ATTRIBUTED thousands of mostly unsigned vases on stylistic grounds to
Archaic and Classical artists. He identified the painters either from their
SIGNATURES or, more often, by defining the stylistic personalities of hundreds
of anonymous artists and assigning them names. To a significant degree, his
life's work remains the foundation of all modern vase scholarship and a well-
spring for the future. See also ARTISTS' NAMES.

BILINGUAL

Vases are called bilingual when they "speak" two languages, that is, when they are painted in two techniques, black-figure on one side and red-figure on the other. Their painters are called *bilingual artists*. See ANDOKIDES PAINTER, LYSIPPIDES PAINTER, OLTOS, PSIAX. FIGURES 20–21

FIGURE 65.
BLACK-FIGURE
Typical black-figure painting with incised details for Herakles and the Triton. Detail of exterior of black-figured EYE-CUP (Type A) attributed to Andokides as potter and painted in the manner of the LYSIPPIDES PAINTER, about 520. Malibu, JPGM 87.AE.22. (Cf. figs. 72, 87.)

BLACK-FIGURE TECHNIQUE

This technique for painting vases, invented in CORINTH around 700 B.C. and subsequently adopted by Athenian vase-painters, shows figures in black painted silhouette against the lighter-colored unpainted RESERVED CLAY background or against ADDED WHITE.

To paint a vase in black-figure technique, its surface was first BURNISHED and polished; then an OCHER wash might be applied and the surface burnished again. A PRELIMINARY SKETCH outlined the design of the figures, which were then filled in with black GLOSS; red or white COLORS were sometimes applied on top of the black. Before FIRING, INCISIONS were made through the black gloss or the COLORS with a sharp pointed TOOL to delineate details of the figures in the lighter color of the underlying clay. FIGURES 4, 5, 10, 19, 20, 24, 29, 30, 31, 34, 35, 36, 37, 39, 43, 54, 55, 59, 65, 72, 76, 78, 79, 81, 87, 95, 98, 100, 103, 108, 109, 117, 120, 122, 126, 127, 138

BOBBIN

Vase shaped like a yo-yo or a pulley: two back-to-back disks, connected by an axlelike cross-piece with a picture on each disk. The shape is rare, occurring in red-figure and WHITE-GROUND. Although neither the ancient name nor the purpose of this form is known, the subjects depicted on bobbins suggest that they had some erotic or magical purpose. It is probable that a bobbin was meant to be suspended by a cord wound around the cross-piece or threaded through the small holes seen on some examples. There is little reason to think that bobbins actually were either ordinary yo-yos or toys or bobbins for thread. FIGURES 66–67

FIGURE 66.
BOBBIN
Zephyros and Hyakinthos. One side of white-ground bobbin attributed to the Penthesilea Painter, about 460–450. Diam: about 12.5 cm (4⅞ in.). New York, MMA, Fletcher Fund, 1928, 28.167. Photo © 2001 MMA.

FIGURE 67.
BOBBIN
Profile of bobbin, figure 66, showing how the two halves are put together.

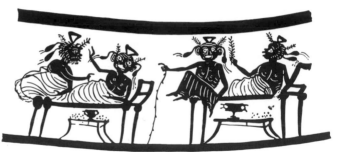

FIGURE 68.
BOIOTIAN
Cabiran-style symposiasts
(banqueters). KANTHAROS
attributed to the WORKSHOP
of the Mystae Painter,
late fifth century. Once
Berlin (now lost),
Antikensammlung 3286.
Drawing by Peggy Sanders,
after Cook, *Greek Painted
Pottery*, fig. 13.

BOIOTIAN

Of or relating to the region of Boiotia, northwest of Athens, of which Thebes
is the capital. The pottery WORKSHOPS of Boiotia were heavily influenced by
ATTIC styles, often copying them, but never competing with them in quality
or trade. Boiotian CLAY tends toward a dull brown; the favorite shape was the
KANTHAROS. A late black-figure style called *Cabiran* (after the sanctuary at
Kabirion, west of Thebes, where much of this pottery has been found) was
produced from the late fifth into the fourth century B.C. Though never so-
phisticated, the decoration on Cabiran pottery can be amusingly lively—
what looks like a parody of a symposium (male drinking party) suggests
inspiration from theater masks and costumes. FIGURE 68

BURNISHING

An essential step in creating a perfectly smooth surface of the vase in prepa-
ration for painting. When the CLAY was LEATHER-HARD but not yet com-
pletely dry, the surface of the vase was vigorously rubbed with a hard, smooth

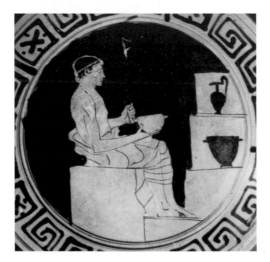

FIGURE 69.
BURNISHING
Potter burnishing a
vase. TONDO of
red-figured KYLIX
attributed to a
follower of DOURIS,
470–460. Staatliche
Museen zu Berlin—
Preußischer
Kulturbesitz,
Antikensammlung
F 2542.
Photo Rosa Mai.

object, most likely leather, wood, or a smooth stone. Burnishing compacts and smoothes the surface of the clay and makes it shiny; it also makes the surface less susceptible to abrasion. To further enhance the appearance of the vase surface, a light coating of OCHER wash could be brushed on the vase; when the wash had dried, the vase would be burnished once more before it was painted. FIGURE 69

CABIRAN See BOIOTIAN.

CHOUS See OINOCHOE, shape 3.

CLASS

Vases of the same shape that are nearly identical or similar in the details of potting or form are said to belong to the same Class. Classes may include the work of several vase-painters and, just like painters, the Classes are named in various ways (see ARTISTS' NAMES and GROUP).

CLAY

Composed mainly of fine particles of aluminum oxide and silicon dioxide mixed with water and impurities, clay is abundant worldwide. As early as the Neolithic period man knew of the plasticity of clay and how it changed from a soft, malleable substance when moist to a hard material after exposure to raised temperatures. Two major groups of clays are distinguished: primary,

FIGURE 70.
CLAY
Digging or mining clay in a pit.
CORINTHIAN PINAX, about 600–575.
H: 10.4 cm (4⅛ in.).
Staatliche Museen zu Berlin—Preußischer Kulturbesitz, Antikensammlung F 871.

FIGURE 71.
CLAY
Athena with Herakles
battling the Hydra,
with a crab nipping at
the heel of Herakles.
Pale clay typical
of CORINTH, with
INSCRIPTIONS in the
Corinthian script.
ARYBALLOS, about
600–575. H: 11.2 cm
(4⅜ in.). Malibu,
JPGM 92.AE.4.

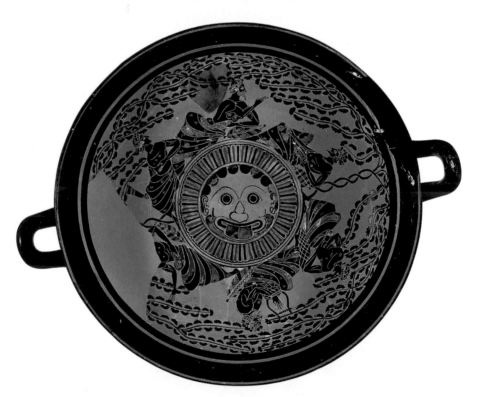

FIGURE 72. **CLAY**
Symposiasts (banqueters). The distinctive warm reddish tone of ATTIC clay. Interior of a black-
figured EYE-CUP (Type A) attributed to Andokides as potter and painted in the manner of the
LYSIPPIDES PAINTER, about 520. Diam: 36.4 cm (14⅜ in.). Malibu, JPGM 87.AE.22. (Cf. figs. 65, 87.)

or residual, clays and secondary, or sedimentary, clays. Clays that have remained at the site where they were formed are called primary. Secondary clays have been moved from the site of their formation by the action of atmospheric or water forces, and their composition is impure, that is, they are mixed with various organic and mineral particles (iron oxide, calcium carbonate, sand, stones, mica, feldspar, and organic matter). Through the process of weathering, the clay particles of secondary clays become very fine and therefore more suitable for the manufacture of pottery. However, not all secondary clays will produce ceramics with similar qualities. The proportion of the various impurities in the composition of the clay determines its porosity, plasticity, strength, and color. Those properties in turn determine which clays are more suitable for the production of sophisticated and richly decorated vases and which are for coarse cooking and storage ware.

The clays of Greece vary greatly from one place to another in texture, color, malleability, and FIRING property. ATTIC clay — one of the finest in the world — is secondary clay, rich in feldspars, quartz, and mica. It has excellent plastic properties and a characteristic rich orange-red color when FIRED due to the significant iron oxide content. With access to a material of such excellent quality, Attic potters were able to craft impressively complex and sophisticated shapes. CORINTHIAN clay is likewise very finely textured, but its greater content of calcium gives it a paler tone that tends toward yellow.

Clay that has just been dug from a clay pit contains many impurities sand, small pebbles, organic material, etc. These must be removed before the clay can be used for making pottery, or the vase will crack during firing. To PURIFY the clay, it is mixed with a large quantity of water and left to settle in a large basin. When heavy materials such as stones have settled to the bottom, the upper layer with fine particles of clay is moved to an adjacent basin, where the water is allowed to evaporate. This process, called *levigation*, takes time and is repeated until the clay has reached the necessary level of refinement. The refined clay is then left to age, a process that improves its working properties. For coarse ware less purification is needed, while heavily refined clay is required for making fine painted vases. See also WEDGING. FIGURES 70, 71, 72

FIGURE 73.
CLAZOMENIAN
Clazomenian
sarcophagus with
friezes of animals and
battling *hoplites* (foot
soldiers), 480–470.
L: 221.5 cm (87¼
in.). Malibu, JPGM
77.AD.88.

CLAZOMENIAN

An EAST GREEK school of pottery production, centered in the town of Cla-
zomenae on the west coast of modern Turkey. The city is best known for its
production of ceramic sarcophagi decorated in black-figure technique (from
the mid-sixth into the early fifth century B.C.), which were commonly used in
East Greece. On these sarcophagi the trapezoidal rim provided a flat surface
for decoration, whose elaborate character increased, presumably, with the
wealth of the client. The favored motifs were a mixture of human figures and
animals; scenes of combat are interspersed with rows of fantastical creatures
rendered in a style that suggests influence from both the WILD-GOAT and
ATTIC styles. The CLAY is coarse and deep red; ADDED COLORS (now mostly
lost) were often thickly applied. FIGURE 73

COLOR (POLYCHROMY)

The only pigments known to Greek potters that could survive the high tem-
peratures in the KILNS were white, red, and yellow. They are referred to as
added colors, for they were applied—that is, added—after the black-glossed

FIGURE 74.
COLOR
The wreaths worn
by this amorous pair
about to kiss are
painted in ADDED
RED. Detail of the
TONDO of a red-
figured KYLIX (Type B)
attributed to the
Carpenter Painter,
about 515–510.
Malibu, JPGM
85.AE.25.

FIGURE 75.
COLOR
The red used on
this round-bodied
CORINTHIAN PYXIS
is of a warm tonality;
in this case the red
is used equally
on ornaments and
figures. Perhaps
painted by the
Chimaera Painter,
about 570. H: 21.8
cm (8½ in.). Malibu,
JPGM 88.AE.105.

areas and figural elements were completed. Painted on sparingly with a brush
before FIRING, the added colors have matte surfaces, in contrast to the sheen
of the black GLOSS.

White, produced from fine white CLAY, was used for the skin of women,
and details of clothes, shields, furniture, etc. WHITE-GROUND vases had the
same white clay applied to their surface before the decorative painting was
applied on top of the white ground. Adding yellow OCHER to the very fine
white clay produced a yellow paint. Red, both purple and brown tints made
of red iron oxide, was frequently used on black-figured vases for garments,
blood, INSCRIPTIONS, wreaths, bands, and other details, usually applied over
the black gloss.

Additional colors such as blue and green were sometimes used to pro-
vide a more luxurious effect, particularly but not exclusively on vases des-
tined for funerary use. These unstable colors were made from vegetable dyes
and minerals. Because the colors would not withstand the temperature in
the kiln, they were applied to the surface of the vase after firing. Because of
their instability, such colors suffer considerably under hostile environmental
conditions. Often only traces of pigment remain on the surface of an object.
FIGURES 7, 10, 40, 52–53, 60, 74, 75, 81, 91, 96, 115, 117, 138

Dinos (pl. dinoi)

Large, round-bottomed bowl without handles; like a KRATER, it was used for mixing wine and water. Although a common shape in metal, the dinos was less popular in ceramics than the krater, probably because the dinos required a stand, either a cylindrical ceramic one (usually made separately) or a metal tripod. The name is ancient (Gr. δîνος, whirlpool or eddy), yet very likely now wrongly applied to this shape which, possibly, in antiquity was called *lebes* (Gr. λέβης; see also LEBES GAMIKOS). There is literary evidence that the *dinos* was, in fact, a type of CUP. FIGURES 81–82

Dipinto (pl. dipinti)

A painted mark on a vase is called a *dipinto* (Italian, painting). Far less common than GRAFFITI, dipinti were usually painted in red OCHER on the vase after FIRING; the relatively few dipinti in black GLOSS were executed before firing. For the forms and functions of dipinti, see GRAFFITO. FIGURE 83

FIGURE 83.
DIPINTO
Dipinto painted on the underside of the foot of a vase. Vases with dipinti such as this were widely exported throughout the Mediterranean. Detail of black figured STAMNOS attributed to the Beaune Painter, around 500. Malibu, JPGM 86.AE.106. Drawing by Peggy Sanders

Dish

Small PLATE, similar in shape to a modern saucer, but in varying sizes. *Dish* is not a term for an everyday serving plate; although relatively common in all-black or plain unglossed ware, black- and red-figured dishes are rare. Both footed (stemmed, like a KYLIX) and footless dishes are known.

East Greek

This term denotes the pottery of the eastern Greek region (the eastern Aegean islands and the west coast of modern Turkey), as distinct from the ceramics produced on the mainland of ancient Greece. East Greek pottery comprises a number of styles and wares, such as the WILD-GOAT STYLE and CLAZOMENIAN. FIGURES 73, 139

EIGHTH-OF-AN-INCH STRIP See OUTLINE.

EPINETRON (pl. EPINETRA)

Woolworker's thigh- and knee-guard; a thick half-cylinder open at one end and closed at the other, the closed one corresponding to the knee. The exact use of the epinetron (Gr. ἐπίνητρον) is uncertain, but at some step in the woolmaking process after carding and perhaps before spinning, the fibers were rubbed across the top of the epinetron, which was roughened by an incised pattern. The closed knee end was sometimes decorated with a moldmade female head, appropriate because woolworking and weaving were women's work. Some figured epinetra may have been given as wedding presents. *Onos* (Gr. ὄνος, pl. *onoi*) is often used interchangeably with *epinetron*, but the onos was the woolworker's footrest rather than a knee-guard. FIGURES 28, 84

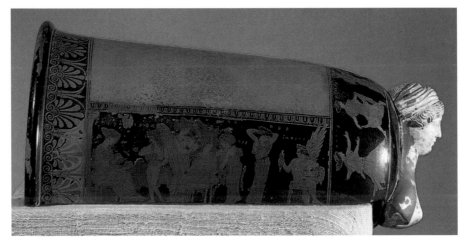

FIGURE 84. **EPINETRON**
The bride Harmonia with Aphrodite and attendants. Red-figured epinetron attributed to the
ERETRIA PAINTER (NAME VASE), about 425. L: 28.7 cm (11¼ in.). Athens, National Museum 1629.

EUBOIAN

Eretria, the major city on the island of Euboia, north of Attica, produced its most distinctive pottery during the ORIENTALIZING period (700–600 B.C.), though production continued at least until the late fifth century B.C. The favored shape was a large AMPHORA used for burial. The neck is broad, and the body has a high center of gravity above a conical foot. Files of women often appear on the front of the neck, with single animals on the shoulder below. The style is a combination of OUTLINE PAINTING and POLYCHROMY, rather than

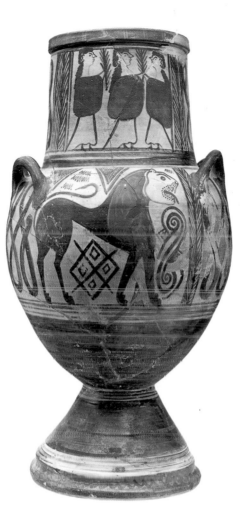

INCISION. In general, the decoration is close to that found in CORINTHIAN, BOIOTIAN, and ATTIC pottery—a testimony both to the close connections of pottery WORKSHOPS and to energetic trade. FIGURE 85

EXALEIPTRON (pl. EXALEIPTRA)

Container for liquid, perhaps perfume (scented oil), with a very distinctive shape: an oblate spheroid bowl with turned-in rim, short or tall foot, and lid with finial (the lids are rarely preserved). The turned-in rim seems intended to prevent the contents from spilling out. In vase-paintings the exaleiptron (Gr. ἐξάλειπτρον) appears most frequently in scenes of women bathing or participating in funerary rituals. The word *exaleiptron* is ancient, and it may have been the name used in antiquity. Other ancient vase names have been

used for this form in modern times: *kothon* (Gr. κώθων, a soldier's drinking cup), *plemochoe* (Gr. πλεμοχόη; in Greek that name brings to mind the function of the shape's turned-in rim: πλήμη, brimming over, and χέω, to pour), and infrequently also *sme(g)matotheke* (Gr. σμηημᾰτοθήκη). FIGURE 86

EXTRUDED See RAISED DOTS.

EYES (EYE-CUP)

Pairs of large eyes decorate the exterior of some vases, appearing most frequently on KYLIKES of Type A, known as *eye-cups*, but also on other shapes such as neck-AMPHORAE and KRATERS (see fig. 98); most examples are black-figured, but many exist in early red-figure too. Most eyes are male, characterized by the stylized tear duct in the inner corner, and readily distinguished by their general contour from female eyes, which are almond shaped and lack the tear duct. Some are animal rather than human eyes. Many eyes are believed to have had an apotropaic function, that is, they were meant to avert evil spirits, but others have different meanings, including endowing a vase with sight. Some may have been no more than decorative patterns. Because eyes appear so frequently on wine cups, it is presumed that they are symbols of the wine god Dionysos—perhaps his wide-eyed drunken stare?—but they have been associated also with the eyes of the god's inebriated companions, satyrs and maenads, and with the masks worn by actors in Greek theater, which was also within the realm of Dionysos. Eyes sometimes expand into

a partial face: eyes and nose—usually the wide nose of a satyr or of the Gorgon Medusa—and, occasionally, ears too. Large staring eyes are prominent also in the masklike full faces of Dionysos and Medusa that mainly appear on black-figured cups and neck-amphorae. No connection has been established between eyes on Greek vases and the Egyptian *udjat*, the "eye of Horus." FIGURES 87, 98

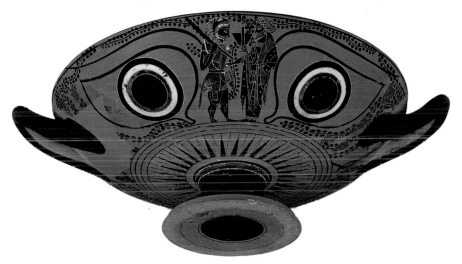

FIGURE 87. **EYE-CUP**
Herakles and Dionysos between eyes. TOOL MARKS remain from the use of a compass to delineate the eyes. Black-figured eye-cup (Type A) attributed to Andokides as potter and painted in the manner of the LYSIPPIDES PAINTER, about 520. Diam. 36.4 cm (14⅛ in.). Malibu, JPGM 87.AE.22.
(Cf. figs. 65, 72.)

FIRING

Subjecting CLAY to high temperature (at least 450°C) creates a hard, porous material that maintains its shape permanently. The Greeks air dried their unfired pottery before stacking it in the KILN. Moisture remaining in the clay evaporated while the kiln chamber warmed up. Conditions inside ancient kilns were carefully controlled, possibly by monitoring small test pieces that were removed from the kiln through a spy hole.

The brilliant effect of figured ATTIC vases with their characteristic lustrous black GLOSS and RESERVED areas of orange-red was produced by a three-step firing process consisting of a single cycle of oxidizing, reducing, and reoxidizing atmospheres in the kiln. The heat and oxygen were carefully adjusted to assure that the required physical and chemical reactions would occur during each step of the cycle.

Oxidizing phase. Its significant content of ferric oxide (Fe_2O_3) gives Attic clay a reddish color. The black gloss, made from the same clay, contains

ferric oxide as well. When fired in an oxidizing atmosphere, the reserved and the glossed areas will both turn red. This occurs when the temperature of the kiln reaches about 800°C and air, admitted through a vent, brings oxygen into the firing chamber. Thus, during the oxidizing phase the reserved clay areas fire to a light red, while the gloss turns a brownish red (fig. 88b).

Reducing phase (reduction of oxygen in the kiln). In the middle of the firing process the temperature of the kiln was increased to 950°C, the air vent was closed, and moisture was added (possibly in the form of green wood and leaves or damp sawdust introduced into the kiln), causing incomplete combustion. As a result, instead of carbon dioxide (CO_2), which is present if the combustion is complete, carbon monoxide (CO) was produced in the kiln. Since oxygen was prevented from entering the kiln, the carbon monoxide combined with the oxygen molecules of the red ferric oxide (Fe_2O_3) in the clay, chemically changing it to a black ferrous oxide (FeO) or to the even

FIGURE 88. **FIRING**
Approximate or simulated color changes during the firing process of a vase. *a* before firing; *b* oxidizing phase; *c* reducing phase; *d* reoxidizing phase. Red-figured KANTHAROS signed by NIKOSTHENES as potter and attributed to the Nikosthenes Painter, 520–510. H: 23 cm (9¹⁄₁₆ in.). Boston, MFA, Henry Lillie Pierce Fund, 00.334. Courtesy, MFA, Boston. © 2001 MFA, Boston. Digital reconstruction by Maya Elston.

blacker magnetic oxide of iron (Fe_3O_4). The chemical reaction that took place during the reduction cycle turned the reserved areas of the vase to a matte dark gray color while the gloss, which was made of finer clay particles, SINTERED to a deep, shiny metallic black (fig. 88c).

 Reoxidizing phase. During the last phase of firing the kiln was gradually cooled to about 900°C and some oxygen was allowed to enter the firing chamber through the vent. This changed the atmosphere in the kiln from reducing back to oxidizing. The oxygen combined with the more porous reserved clay, reverting its matte gray to an orange-red color. The black gloss, however, retained its black color, for its sintered surface could no longer absorb oxygen, so no further chemical reaction occurred (fig. 88d). FIGURES 76, 88, 97

FISH PLATE

 Footed platter for serving fish at the table. Fish plates were produced from the beginning of the fourth century B.C. well into the Hellenistic period not only in ATTICA, but also by the Greeks in South Italy, where the shape was especially popular. Its broad flat surface slopes down to a small well in the center for sauce or fish juice. Fish plates are invariably decorated with a profusion of sea creatures (principally fish), and painted in a wide variety of styles. Athenian painters always oriented the bellies of the fish toward the rim of the plate, while South Italian painters positioned them the opposite way, with the bellies toward the center. Androkydes of Kyzikos was one of the very few fish-plate painters who signed his work. See also PLATE. FIGURE 89

FIGURE 89.
FISH PLATE
ATTIC red-figured fish plate attributed to the Scorpion Fish Painter, 400–350. Diam: 22.5 cm (8⅞ in.). Malibu, JPGM 86.AE./00.

Figure 90.
GEOMETRIC
Geometric neck-
AMPHORA attributed
to the Dipylon Painter,
about 750. H: 155 cm
(61 in.). Athens,
National Museum
804.

Flaws See DEFECTS.

GEOMETRIC

Geometric is the name both of a period—about 900–720 B.C.—and of a style. The style was prevalent throughout the Greek world, but the most sophisticated examples survive from ancient Athens. There, Geometric vases of majestic size, particularly AMPHORAE and KRATERS, were used as grave markers and at times contained cremated human remains and showed funerary scenes. These vases comprise the earliest monumental form of Greek art. The highly skilled potting is paired with a characteristic use of dark painting on light ground. The motifs generally derive from textile patterns, the most distinctive being the MEANDER. FIGURE 90

GILDING

Application of gold to embellish the surface of a vase. Very thin gold leaf was in rare cases applied to ATTIC vases to accentuate details of wings, wreaths, garlands, necklaces, and other decorative elements. It was usually applied over a CLAY pattern in relief (see RAISED DOTS AND LINES). The clay surface may have been coated with egg white, plant gum, or some other adhesive substance onto which the gold leaf was pressed and then BURNISHED when dry. The gilding may have been applied either before or after firing. FIGURE 91

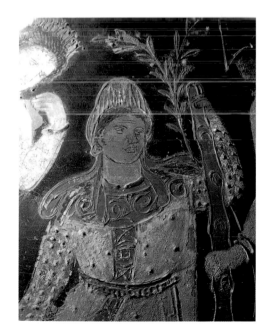

FIGURE 91.
GILDING
Judgment of Paris on a KERCH STYLE vase with profuse use of the ADDED COLOR and gilding for which this style was famous (see also fig. 96). Detail of red-figured PELIKE attributed to the Painter of the Wedding Procession, about 330–320. Malibu, JPGM 83.AE.10.

Gloss (Glaze)

The shiny black surface so characteristic of Attic ware was produced by the CLAY itself during FIRING. The oxygen alternately present and absent during firing resulted in the black color, while the temperature in the oven SINTERED the clay SLIP and made it appear as "glaze." *Gloss* is generally used to describe a substance containing silica and fluxes, which fuse during firing when sufficiently high temperatures are reached and thus create a glossy surface on the pottery. Since Attic vases use clay slip fired at low temperatures, the glossy surface of these vases is more appropriately called "gloss."

Attic gloss was prepared from finely LEVIGATED clay mixed with alkaline water to the desired consistency. This slip was applied to the LEATHER-HARD surface of the clay body. The vase was either dipped into the slip or, for more complicated designs, the slip was brushed on. The latter method was most often done while the vase rotated on the POTTER'S WHEEL. Since similar clay material was used both for the body of the vase and for the gloss of the painting, it is likely that the ancient Greek craftsman added pigment or dye to the slip to be able to distinguish the drawings from the background. See also DILUTE GLOSS, FIRING, RELIEF LINE.

Graffito (pl. GRAFFITI)

Mark incised or cut into the ceramic fabric of a vase, in contrast to a DIPINTO, which is a painted mark. Graffiti usually are found on the underside of the foot, often in the form of a single letter or linked letters, numerical notations, and, less frequently, words, phrases, and sentences (see also INSCRIPTIONS). In general they are mercantile or TRADEMARKS—abbreviations or symbols inscribed (usually after firing rather than before) by the potter or the seller, primarily on vases intended for export. The precise meaning of most of these

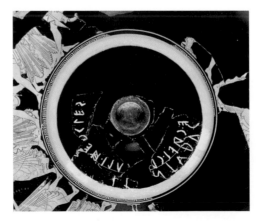

FIGURE 92.
GRAFFITO
Etruscan votive graffito scratched into the foot of a KYLIX dedicating it to Herakles. Underside of foot of an ATTIC red-figured kylix signed by EUPHRONIOS as potter and attributed to ONESIMOS as painter, about 500. Rome, Villa Giulia 121110 (formerly JPGM 83.AE.362).

marks is obscure, but some are definitely price inscriptions or marks of ownership. Occasionally single letters were scratched into a vase and its lid so they could be matched by the potter after FIRING. See also DIPINTO. FIGURE 92

GROUP

Vases or vase-painters that are closely related to each other in the details of their drawing style are said to belong to the same Group. Like painters, Groups are named in a variety of ways (see ARTISTS' NAMES, CLASS).

HEAD-VASE

Vase partly in the shape of a moldmade head (or face). In the case of ARYBALLOI, KANTHAROI, MUGS, OINOCHOAI, or RHYTA, the head usually constitutes the body of the vase. As a rule, all other parts of a head-vase (except the handles) are wheelmade. Animal heads predominate on rhyta: boar, bull, cow, crocodile (attacking an Ethiopian youth), deer, donkey, goat, hound, lion, griffin, and ram. Human faces or heads are characteristic on other

FIGURE 93.
HEAD-VASE
KANTHAROS head-vase, note KALOS (beautiful) written on the wineskin by the feet of the satyr. Red figured head-vase attributed to the BRYGOS PAINTER, about 500–470.
H: 19.7 cm (7¾ in.).
New York, MMA, Rogers Fund, 1912, 12.234.5. © 1990 MMA.

shapes: Ethiopian, Dionysos, Herakles, satyr, and woman. A *janiform head-vase* consists of two different heads back-to-back. FIGURES 93, 94, 135

HYDRIA (pl. HYDRIAI)

Water jar; one of the most common shapes. The name *hydria* (Gr. ὑδρία) is ancient (from Gr. ὕδωρ, water). A hydria's two horizontal handles (on the sides) were for lifting the vase when full; the vertical one (at the back) was for pouring or for carrying the empty hydria. Pictures on vases show women carrying hydriai on their heads when fetching water at a fountain house: the hydria was carried horizontally when empty and vertically when full (see fig. 10). Hydriai also served as general-purpose containers (like AMPHORAE and STAMNOI), and they had important funerary uses, too, as burial containers for children, secondary cremation ash urns, and gifts brought to the grave.

In black-figure the standard form was a very substantial vase (sometimes called a *shoulder-hydria*), distinguished by its large round mouth, offset neck, broad flattish shoulder, and wide body. Some early black-figured hydriai are ovoid- or round-bodied, similar in shape to neck-amphorae. The shoulder-hydria continues in red-figure, but the usual red-figured form was the *kalpis* (Gr. κάλπις, pl. *kalpides*), easily recognized by its one-piece body—continuously curved from neck to foot—as well as its smaller mouth and narrower

neck (see fig. 42). Although the kalpis was introduced after the invention of red-figure, there are both black- and red-figured kalpides. Unlike the modern distinction between the two shapes, in antiquity *kalpis* denoted both forms of the hydria. Hydriai and kalpides were frequently made also in bronze and, unlike the metal versions of other shapes, a significant number survives. FIGURES 10, 42

INCISION

Sharp fine line cut into a ceramic body to delineate details of a design or to write INSCRIPTIONS. Incised lines are characteristic of the black-figure technique. Used extensively to delineate the CONTOUR and details of figures, incisions were usually made before FIRING, when the vase was at the LEATHER-HARD stage, almost always cutting through the GLOSS or ADDED COLORS to the clay body. The dampness of the CLAY had to be just right to allow delicate incisions with smooth edges to be made, and presumably a sharp-pointed metal TOOL was used. It is possible that some of these lines were reincised after firing. FIGURE 95

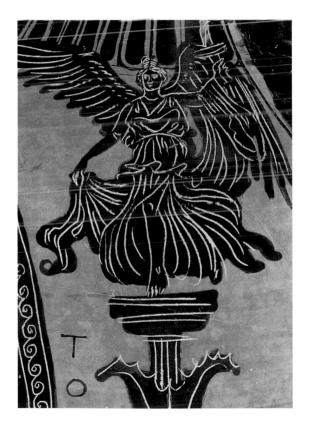

FIGURE 95.
INCISION
Incised lines give expression to this Nike alighting on top of a column. Detail of PANATHENAIC PRIZE AMPHORA attributed to the Painter of the Wedding Procession and signed by Nikodemos as potter, from 363/362 B.C. Malibu, JPGM 93.AE.55.

INSCRIPTIONS

Letters, words, or phrases written on a vase, usually before FIRING. In black-figure inscriptions are usually painted in black GLOSS; in red-figure they are most often in dark red (and, less frequently, RESERVED or INCISED). A typical inscription consists of very few words, such as those used in SIGNATURES, KALOS INSCRIPTIONS, and on PANATHENAIC AMPHORAE (cf. GRAFFITI and DIPINTI, inscriptions generally made after firing). Inscriptions often identify a character, an object, or (rarely) the picture itself (see fig. 55). Some longer inscriptions are phrased as if the vase itself were speaking, describing its dedication to a god or recording the owner's name, for example; others are brief excerpts from a conversation, words spoken by one or more of the figures depicted (see fig. 29), or, in a unique instance, even commenting on another painter's abilities (see p. 1); misspellings are common. Most inscriptions are written from left to right, but many are *retrograde*, that is, written from right to left (with the letters turned around to face left). In black-figure many inscriptions are meaningless combinations of letters—so-called *nonsense inscriptions*—presumably intended to give the impression that the vase-painter was literate. FIGURES 3, 4, 27, 29, 31, 55, 71, 117, 138

JANIFORM VASE See HEAD-VASE.

JOINING See LEATHER-HARD.

KALOS INSCRIPTIONS

Kalos inscriptions are love inscriptions that reflect, primarily, male homosexuality in Athenian life. They name a young man and praise him as *kalos* (Gr. καλός), which translates as handsome or beautiful but, in this context, carries with it an erotic connotation—in a word, sexy. The form of the inscription invariably is "so-and-so [is] kalos." It is certain that some of the men so named were Athenian aristocrats—one of the most frequently praised was Leagros (the LEAGROS GROUP of painters is named after the common use of his name on their pots). From the historical record as well as vase-paintings it may be inferred that youths were *kalos* in their early teenage years. Some kalos inscriptions just state "the boy [is] kalos" (Gr. ὅ παῖς καλός), without naming anyone in particular. There are *kale inscriptions* for women (Gr. καλή, the feminine of *kalos*), but these are outnumbered by kalos inscriptions more than twenty to one. Far less is known about the women called *kale*, but some at least were prostitutes. Most kalos inscriptions are on vases made between 550 and 450 B.C. FIGURES 3, 29, 54, 93

KALPIS (pl. KALPIDES) See HYDRIA.

KANTHAROS (pl. KANTHAROI)

Wine cup with two vertical handles and a deep, footed bowl. Its most characteristic form—the kantharos of Type A (see fig. 88)—is easily recognized by the two large looped handles that rise above its deep bowl, and by its tall stem and foot. The lower part of the bowl is slightly offset from the upper part. Although *kantharos* almost certainly was the shape's ancient name, in Greek *kantharos* (κάνθαρος) happens also to be the word for the Egyptian scarab beetle. Any connection between the two meanings of the word, however, seems very unlikely. *Kotylos* (or *kotyle*; Gr. κότῠλος, κοτύλη) is apparently another ancient name for the shape. The kantharos is intimately associated with Dionysos, the wine god, who is commonly depicted on vases holding either a kantharos Type A or a RHYTON.

Of the principal forms of kantharoi, *Type A* (described above) is the most familiar. The chief characteristics of the others follow. *Type B:* handles smaller than Type A, rising only to the rim of the bowl; torus (tire-shaped) foot with very short or no stem. *Type C:* handles as in Type A, continuously curved bowl, torus foot with very short stem. *Type D:* handles and bowl as in Type C, small torus foot with no stem; the *Sotadean kantharos* is a variant of Type D, named for the potter SOTADES. *Sessile kantharos:* handles and bowl much as in Type B, small torus foot (no stem), bowl usually decorated with patterns rather than figures (the botanical term *sessile* denotes something sitting directly on its base). Other forms of the kantharos include: *head-kantharos* (see HEAD-VASE), *mask-* or *face-kantharos* (the bowl in the form of back-to-back, or janiform, faces [see fig. 94]), *plastic kantharos* (see PLASTIC VASE), and *one-handled kantharos* (a black-figure shape). FIGURES 17, 19, 88, 93, 94, 110

KERAMEIKOS

The potters' quarter in ancient Athens; the name is derived from the Greek word for potter's CLAY, *keramos* (κέραμος). The nearby cemetery, just outside the city gates, was called Kerameikos because of its proximity to the potters' quarter.

KERCH VASES (or KERCH STYLE)

General term for certain red-figured vases of the fourth century, distinctively decorated with GILDED details in low relief and ADDED COLORS such as blue, green, and white. Although the vases were made in Athens, the style is named for the city of Kerch (ancient Pantikapaion) in the eastern Crimea, where many of these vases have been discovered. See also MARSYAS PAINTER. FIGURES 40, 91, 96

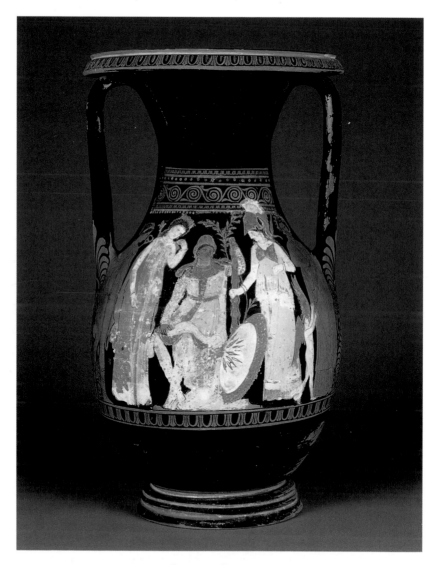

FIGURE 96. **KERCH VASE**
Judgment of Paris. Red-figured PELIKE attributed to the Painter of the Wedding Procession, about 330–320. H: 48.3 cm (19 in.). Malibu, JPGM 83.AE.10.

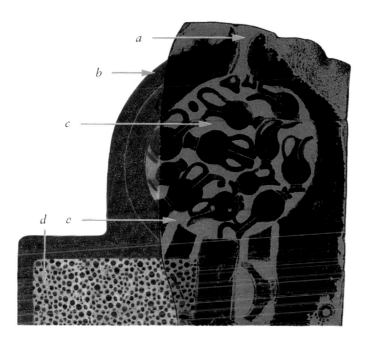

FIGURE 97.
KILN
Plan of a kiln: *a* vent
hole; *b* exterior wall
of kiln; *c* stacking
chamber with pots;
d stoking tunnel with
fuel; *e* perforated floor
of kiln. CORINTHIAN
PINAX, about 600.
H: 10.1 cm (4 in).
Staatliche Museen zu
Berlin—Preußischer
Kulturbesitz,
Antikensammlung
F 893. Digital
reconstruction (in
gray) by Maya Elston.

KILN

Enclosed chamber for FIRING CLAY pottery, which transformed the material into hard ceramic. Pottery kilns were first introduced around 3400 B.C. in Sumeria (ancient Mesopotamia, modern southern Iraq).

The Greeks commonly used an updraft kiln (the term indicates the direction of air circulation). Excavated kilns from archaeological sites have been quite damaged, so the few illustrations of kilns on Greek pottery provide our best information about their shape and compartments. Kilns were probably built of mud, clay, and stones. They consisted of a stoking tunnel; a firing, or combustion, chamber where the fire burned; and a vaulted chamber above the firing chamber, where the pottery was stacked. The floor of the stacking chamber was pierced to allow the heat to circulate around the pots. A vent or chimney on the roof supplied air as needed, released smoke from the kiln, and was used to control the temperature, which was crucial to the whole process. A spy hole, likely part of the stacking chamber's door, allowed the potter to monitor the progress of the firing. To save space, small vases were sometimes placed inside larger ones. See also FIRING. FIGURES 76, 97

KOTHON (pl. KOTHONES) See EXALEIPTRON; for tripod-kothon, see PYXIS.

KOTYLE (pl. KOTYLAI) or **KOTYLOS** (pl. KOTYLOI) See KANTHAROS and SKYPHOS.

KRATER (pl. KRATERS or KRATERES)

Large bowl with wide mouth and heavy foot, used for mixing wine and water; in antiquity wine was customarily diluted with at least an equal amount of water rather than consumed straight. The name κρᾱτήρ, which is ancient, derives from the Greek verb κεράννυμι, to mix. Our word *crater*—meaning a bowl-shaped depression—comes from this vase shape.

The basic forms of the krater are named for the shape of the body or the handles. In a *skyphos-krater* (also known as a *kotyle-krater*), an early black-figure shape (but invented earlier, in the Late GEOMETRIC period), the bowl resembles a large SKYPHOS, with separate lid and stand, high horizontal handles, and a simple torus foot. *Column-krater* (fig. 98), especially popular in black-figure: The horizontal handles on the level of the rim are supported

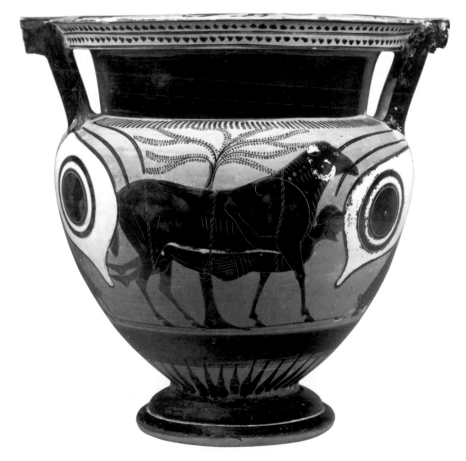

FIGURE 98. **COLUMN-KRATER**
Odysseus escaping from the cave of Polyphemos. (For the EYES, see that entry.) Unattributed black-figured column-krater, about 550–500. H: 33 cm (13 in.). Malibu, JPGM 96.AE.303.

by short, vertical elements that resemble columns; the foot is echinus shaped (in antiquity the vase was called a Corinthian krater). *Volute-krater* (see fig. 45), rare in black-figure, but common in red-figure: Large volute, or scroll, handles rise above the mouth. *Calyx-krater* (see fig. 49), a form said to have been developed by EXEKIAS in black-figure is, however, more characteristically a red-figure form: Its body is shaped like the calyx of a flower, and the foot is stepped. Because the calyx-krater accommodates a PSYKTER so well, it has been suggested that the two shapes sometimes were made as a set. *Bell-krater* (fig. 99), a red-figure form: The rim is offset, the body is shaped like an inverted bell, the handles or lugs (see fig. 47) are placed high on the body, and the foot is stepped. FIGURES 31, 45, 47, 49, 52, 77, 98, 99

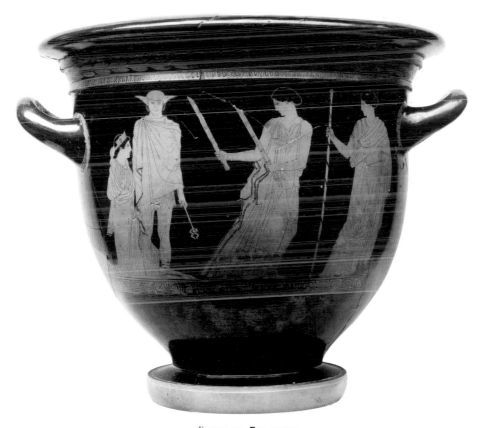

FIGURE 99. **BELL-KRATER**
Return of Persephone. Red-figured bell-krater attributed to the Persephone Painter (NAME VASE), about 440. H: about 41 cm (16⅛ in.). New York, MMA, Fletcher fund 1928, 28.57.23.

FIGURE 100.
KYATHOS
Perseus chasing
Medusa. Black-figured
kyathos attributed
to a follower of the
Theseus Painter,
about 510–500.
H (with handle finial):
14.7 cm (5¾ in.).
Malibu, JPGM
86.AE.146.

KYATHOS (pl. KYATHOI)

Ladle used to serve wine from a KRATER. Although long-handled metal ladles are known as well as depicted on vases, there is no identical ceramic form. The teacup-shaped and thin-walled kyathos, with its high looped handle, is the closest equivalent. It is primarily a black-figure form, which, like the Nikosthenic AMPHORA, was copied from an Etruscan shape. The ancient word *kyathos* (Gr. κύαθος) is probably the general word for ladle rather than the specific name for this shape. FIGURE 100

KYLIX (pl. KYLIKES)

One of the most common ATTIC vases, the kylix (Gr. κύλιξ) is a cup for drinking wine. It is shown in a variety of shapes on countless vases (see fig. 101). Other vases, too, served as drinking cups: KANTHAROI, MASTOI, RHYTA, and SKYPHOI. Only the principal forms of kylikes are discussed here, but there are many others—more than thirty in all.

A kylix is a two-handled bowl on a footed stem. In a broad spectrum of forms the bowls range from shallow to deep and the stem from short to tall; in some varieties, the stem is lacking entirely, so the bowl sits directly on the

foot; the handles are horizontal but curve upward and can have any of a variety of shapes. The Greeks had no shape equivalent to our one-handled tea or coffee cup—the closest is the mug (see OINOCHOE, shape 8). Almost unknown are cylindrical cups without handles, comparable to our ordinary "glasses" or tumblers.

In black-figure the *Komast cup*, the *Siana cup* (see fig. 24), and the *Little-Master cup* (see fig. 35) predominate until about 540 B.C. Komast cups—offset lip, deep bowl, and short conical foot—take their name from the dancing revelers (*komasts*) usually depicted on them. The Siana cup (named for the village of Siana on the Greek island of Rhodes) develops from the komast type—similar offset lip and deep bowl but higher foot. Little Master is a translation of the German word *Kleinmeister*, which makes sense as a reference to the miniaturist character of the pictures that decorate this shape—lip slightly offset, moderately deep bowl, very tall stem and foot—but in fact the term originally was coined for some minor sixteenth-century German artists. The *lip-cup* has a RESERVED bowl and black handles, stem, and foot; figures are regularly painted on the lip (or the lip is undecorated) and/or an INSCRIPTION (often the potter's SIGNATURE) is written in the zone between the handles. The *band-cup* is black all over except for a reserved band in the handle zone decorated with figures, ORNAMENTS, or inscriptions (often the potter's signature). After about 540 B.C. the *Type A kylix*—deep bowl (lip not offset), short stem and foot—dominates black-figure. The ordinary Type A cup is an *eye-cup* (see fig. 87), decorated on the outside with a pair of large

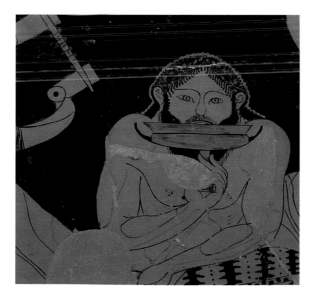

FIGURE 101.
KYLIX
Symposiast (banqueter) drinking from a lip-CUP (rendered in DILUTE GLOSS). The lack of any painted figures on the lip-cup may indicate that it is of metal rather than ceramic. Its shape was old-fashioned by the time this was painted, so the man may be drinking from a family heirloom. Detail of red-figured calyx-KRATER attributed to EUPHRONIOS, about 515–510. Munich, Staatliche Antiken-sammlungen und Glyptothek 8935.

eyes on each side, often with figures painted between the eyes and sometimes figures under the handles, too. On some rare eye-cups, moldmade male genitals substitute for the wheelmade foot.

Other black-figured cup types, each with distinctive characteristics: *Cassel cup*—similar to a band-cup, usually decorated on the outside with PATTERNS rather than figures; *Droop cup* (pronounced "drope")—shaped like a Little-Master cup, patterns commonly decorate the lower part of the bowl (but sometimes there are figures or animals), with a reserved band (generally grooved) at the top of the stem; *Gordion cup*—shaped like a Siana cup, usually with a signature in the reserved zone between the handles; and *Merrythought cup*, with wishbone-shaped handles (merrythought: an old English word for wishbone).

Type A continues in red-figure, but by about 500 B.C. *Type B* supplants it to become the most characteristic red-figured cup (see fig. 38). Unlike the contour of black-figured kylikes, the Type B cup (see figs. 26, 102) is one continuous curve from lip to foot, and the bowl is broad and relatively shallow. The ornamental designs adjacent to and under the handles of most black-figured cups are sometimes omitted in red-figure, maximizing the fields available for the pictures on the exterior. *Type C* resembles B in its general

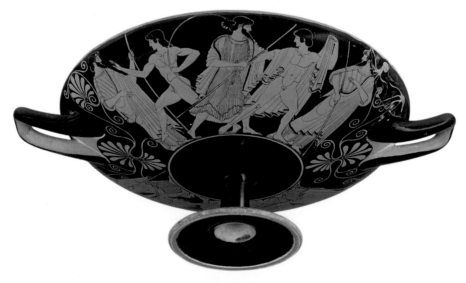

FIGURE 102. **KYLIX**
Zeus pursuing Ganymede. Exterior of a red-figured kylix (Type B) attributed to Python as potter and signed by DOURIS as painter, about 480. Diam: 32.4 cm (12¾ in.). For the TONDO of this KYLIX, see fig. 26; for a detail of its other side, see fig. 130; note the ancient repair at the upper right, cf. fig. 58. Malibu, JPGM 84.AE.569.

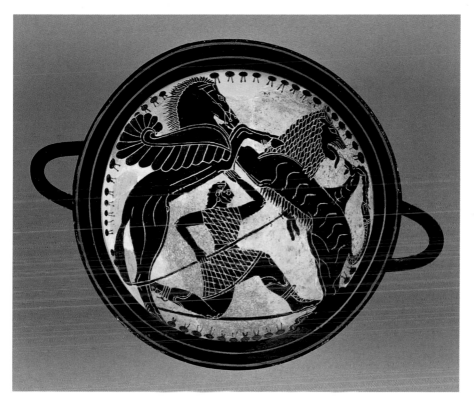

FIGURE 103. **LAKONIAN**
Bellerophon, Pegasos, and the Chimaira. Interior of a black-figured Lakonian KYLIX attributed to the
Boread Painter, about 570–565. Diam. 10.4 cm (7¼ in.). Malibu, JPGM 85.AE.121.

proportions, however, the contour is discontinuous: the lip is often offset from the bowl, and there is a fillet (raised ring of CLAY) between the stem and foot.

Unlike other kylikes, the *stemless cup* was THROWN in one piece, the bowl joined directly to the foot. Of the various black- and red-figured stemless forms, the black-figured *segment cup* is unusual in that one large picture fills the interior of the bowl. In this respect it resembles the *zone cup* (see fig. 16), which is *not* a stemless form; on the inside a central picture is surrounded by a ring-shaped figured zone, or one picture may occupy the entire surface. There are both black- and red-figured examples: the largest kylikes known—up to 56 cm (22 in.) in diameter—are zone cups. FIGURES 14, 16, 24, 26, 35, 38, 46, 48, 50, 72, 87, 101, 102, 103

LAKONIAN

Of or related to Lakonia, the region of the Peloponnese of which Sparta is the capital. The Lakonians produced distinctive black-figured pottery during the Archaic period from around 620 B.C. Although at first inspired by CORINTHIAN vases, by 580 B.C. Lakonian artists had developed their own strong identity. Their favorite shape was a broad-bowl CUP with offset rim and two horizontal handles, supported by a tall and sturdy stemmed foot. The exterior was decorated with ORNAMENTAL motifs; all of the interior was figured, inventively decorated with narrative subjects. The work of a number of Lakonian painters has been identified, but because no Lakonian vase is signed, none of their ancient names are known. Owing to its composition, Lakonian CLAY fires to a pale buff color (in contrast to the Athenian orange-red). The GLOSS used to paint the figures is a lustrous reddish-brown enlivened by ADDED red (sometimes purplish) and white. FIGURE 103

LEATHER-HARD

The stage in the drying of a CLAY vase, after CONSTRUCTION and before painting and FIRING, when the clay reaches leatherlike consistency, that is, it is still somewhat flexible. After the vase was formed, when the clay had dried to the leather-hard stage, sections such as foot and handles were JOINED to the vase with SLIP. For this to be possible, of course, the vase had to be hard enough to allow it to be handled without damage. After the foot and handles were attached, the vase was returned to the wheel to refine its shape and finish detailed sections (see TURNING). At that point fillets and grooves were cut into the mouth, neck, and foot of the vase, and the black GLOSS was applied.

LEBES (pl. LEBETES) See DINOS.

LEBES GAMIKOS (pl. LEBETES GAMIKOI)

Vase used in connection with marriage, although its specific function is uncertain. It is generally thought to be a vase used to hold water for the ritual bath taken before the wedding by the bride—and, perhaps, also by the groom—or it may be a container for the couple's food. The basic shape is similar to that of the lebes (see DINOS), with the addition of one or two upright looped handles on each side. *Lebes gamikos* (Gr. λέβης γᾰμικός) is its ancient name, often translated as *nuptial lebes* (Gr. γᾰμικός, bridal). Of the two forms of the vase, *Type 1* (or *Type A*) is common to black- and red-figure: It has an attached, tall conical stand. *Type 2* (or *Type B*) is a late red-figure shape only. Instead of a stand the vase has an echinoid or disk-shaped foot.

Both types were normally fitted with lids. Pictures of a wedding procession or women preparing for marriage often appear on lebetes gamikoi; however, fragmentary examples discovered in graves, sometimes decorated with mourners, indicate that the shape had funerary uses as well. Other shapes associated with marriage, as shown by pictures on vases, are: ALABASTRA, EXALEIPTRA, LEKYTHOI, LOUTROPHOROI, and PYXIDES. FIGURE 104

FIGURE 104.
LEBES GAMIKOS
Scenes from the women's quarters are typical for a wedding vase like this. A *kalathos* (wool basket) is depicted on the stand, between the two women. Red-figured lebes gamikos attributed to the Washing Painter, about 430–420. H: about 51 cm (20⅛ in.). New York, MMA, Rogers Fund, 1907, 07.286.35.

LEKANIS (pl. LEKANIDES)

Shallow, footed dish with two horizontal handles; seen on vases in connection with weddings and as a container for articles used by women when dressing or grooming, or as a receptacle for small items (such as toys, spices, or thread). Overall the body of the vase resembles a shallow KYLIX (stemmed or stemless), but the lekanis differs in that its upper part has comparatively vertical walls, and it is shaped to take a caplike lid. The lekanis was used also for serving food: its flattish lid has a knob similar to the foot of a kylix; when removed and turned over, the lid becomes a footed bowl or plate. Some lekanides, however, are lidless. *Lekanis* (Gr. λεκᾰνίς) seems to be the ancient name for this shape. In late red-figure, a bride and groom, accompanied by others and in the presence of wedding vases, are routinely depicted on the *nuptial lekanis*. *Lekanis* is sometimes used interchangeably with *lekane* (Gr. λεκάνη) as the name for a footbath (footed basin). FIGURE 105

FIGURE 105.
LEKANIS
Lekanis with lid, about 480–450. H (bowl): 14 cm (5½ in.). The Art Institute of Chicago, Gift of Charles L. Hutchinson, 1889.99. © 2000 The Art Institute of Chicago. All rights reserved. Photo Robert Hashimoto.

LEKYTHOS (pl. LEKYTHOI)

An oil bottle, one of the most common of all shapes, either for scented oil (perfume) or for oil for household purposes such as cooking. The narrow neck of the lekythos limited the flow of oil to drops or a thin stream, while the thick lip prevented wastage. In antiquity *lekythos* (Gr. λήκῠθος) seems to have applied to any kind of oil bottle or jug, including what is known today as an ARYBALLOS. Because lekythoi were routinely buried in tombs and left at graves as gifts to the dead, a vast number has been preserved; artistically many are poor-quality pieces, especially the masses of black-figured lekythoi made after the invention of red-figure, often decorated with PATTERNS rather than figures. Funerary lekythoi are often WHITE-GROUND vases (see fig. 18); some rank among the finest vases decorated in that technique. They were in-

troduced about 500 B.C., and many depict visits to the grave. The dominant
form is the *shoulder lekythos*—calyx-shaped mouth and thick lip, very nar-
row neck, one handle, concave shoulder, cylindrical body, and disk foot—
but there are many variations. The ovoid-bodied *Deianeira lekythos* is an early
black-figure form; in late black-figure the *chimney lekythos* is common, its
mouth and neck resembling an old-fashioned chimney pot. About 490 B.C.
black-figured lekythoi began to be made with a small inner cup hidden inside
the body, attached to the bottom of the neck. The token amount of oil in this
little receptacle was sufficient for a funerary offering. The bulbous-bodied
squat lekythos is a common form in red-figure. FIGURES 7, 18, 106

LEVIGATION See CLAY.

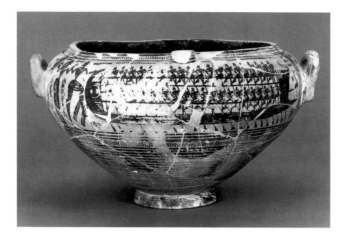

FIGURE 107.
LOUTERION
Man and woman
(Paris and Helen?)
about to board a large
ship. The broken-off
spout is at the center
of the rim. Late
GEOMETRIC louterion,
about 725–700.
H: 30.9 cm (12⅛ in.).
London, BM 1899.2-
19.1. © BM.

LOUTERION (pl. LOUTERIA)

The name presumably is derived from the word for bath (water) (Gr. λουτρόν), which suggests that the vase was used for carrying water for bathing or washing. *Louterion* (Gr. λουτήριον) seems to be the ancient name for a laver or washbasin on a pedestal; however, today the name is more commonly applied—but with much uncertainty—to two additional shapes. One is a large, broad basin with a spout and two upright handles, a relatively rare form, known primarily in early black-figure. It has been likened to a KRATER, yet there is no compelling reason to think that it was a mixing bowl for wine and water. The other shape is rare, too, and known in both black- and red-figure. Overall it resembles a LEBES GAMIKOS, yet it differs in that it has a spouted rim and peculiar handles: high, upright flat handles with looped adjuncts. This shape appears to be connected with funerary rites, and it may have held water intended as an offering to the dead, or for the ceremonial bathing of the corpse. FIGURE 107

LOUTROPHOROS (pl. LOUTROPHOROI)

Jar to hold water used for the ceremonial bath of the bride—and perhaps also the groom—before marriage (cf. LEBES GAMIKOS), for bathing the dead, and as a grave marker. Loutrophoros (Gr. λουτροφόρος) means bath-carrier (Gr. λουτρόν, bath [water], and φέρω, to carry), and while it is certain that a *person* who brought water for the bath was called a loutrophoros, it is not definite that *loutrophoros* also was the name of a *vase*. Nevertheless it is today the accepted name for this shape.

It was common practice to place loutrophoroi on the graves of persons who died unmarried, the idea being that they were married in death. Some

loutrophoroi made expressly for the tomb have holes in the bottom to allow libations to be poured on the grave through the vase. Wedding or funerary scenes predominate on loutrophoroi, but some depict battles or young men on horseback, presumably intended for the tombs of soldiers who died in action. In shape the common loutrophoros—the *loutrophoros-amphora* (see fig. 108)—resembles a tall neck-AMPHORA, but it differs in its narrow proportions and elongated handles, with the space between the neck and handles sometimes partially filled in. The *loutrophoros-hydria* is distinguished by its three handles, two horizontal ones on the sides and a vertical one at the back (cf. HYDRIA). FIGURE 108

FIGURE 108.
LOUTROPHOROS
Mourning scenes; on the neck, a woman cradles a loutrophoros in her arms. Black-figured loutrophoros, about 500. H: 74.9 cm (29½ in.). New York, MMA, Funds from various donors, 1927, 27.228. All rights reserved, MMA.

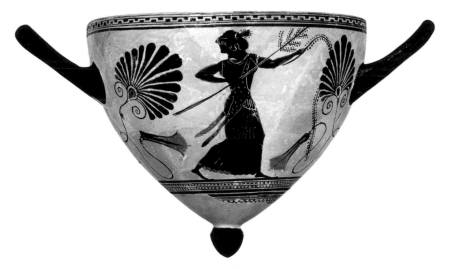

MASTOS (pl. MASTOI)

Wine cup shaped like a woman's breast; principally known in black-figure
and WHITE-GROUND; two handles (both horizontal, or one vertical and one
horizontal), usually with a nipple at the bottom of the bowl rather than a
stem and foot (some footed examples do exist). Mastos (Gr. μαστός, breast)
was likely the ancient name for this shape, but not necessarily the only
one. A *mastoid* is another type of conical cup—not markedly breastlike in
shape—with an offset lip and a flat bottom; some have handles, others do
not. FIGURE 109

MEANDER

The meander was the characterizing motif of the GEOMETRIC style and era.
From the Iron Age on, it was the most familiar ORNAMENTAL pattern on both
black- and red-figured vases. Also called "Greek key," the meander could be
manipulated in varying degrees of complexity. The essential key meander,
running either to left or to right (see fig. 113.15, 17), could be broken (see
fig. 113.16), crossed (see fig. 113.18), or stopped (see fig. 113.19, 20). The
word is derived from the river Meander in Turkey (ancient Asia Minor),
which twists and turns around upon itself like the ancient ornament. See also
ORNAMENT. FIGURES 90, 111, 113.15–20, 120

Miltos See OCHER.

MODELING

Shaping plastic materials, such as CLAY, by hand rather than in a mold. Some decorative elements—handles and spouts, for instance—were modeled free-hand; but apart from that, this technique was not common for Greek vases.

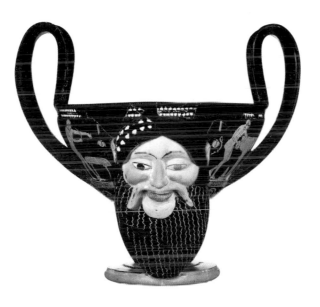

FIGURE 110.
MOLDING
PLASTIC VASES were usually a combination of two separate parts, one moldmade, such as this mask of Dionysos, and the other, the drinking vessel, wheelmade according to traditional pottery methods. Red-figured mask-KANTHAROS, possibly molded by EUPHRONIOS, attributed to the Foundry Painter, about 480. H (with handles): 21.1 cm (8¼ in.). Malibu, JPGM 85.AE.263. (See also fig. 171.)

MOLDING

A mold is a hollow, negative impression of a model. Using a mold to manufacture ceramics allows the potter to make multiple CLAY copies with relative ease. To create a mold, an original model (or prototype) is sculpted, and a mold consisting of two or more sections is made around it. FIRED clay was a common material for molds in antiquity. The fingerprints seen on the interior walls of PLASTIC VASES are evidence that Greek craftsmen pressed soft clay carefully into the interior of molds. Plastic vases shaped as human or animal heads, perfume bottles shaped as birds or animals, as well as some handles were made in molds. See also HEAD-VASE. FIGURE 110

Mug See OINOCHOE (shape 8).

Name vase See ARTISTS' NAMES.

Ocher (wash)

In order to accentuate the naturally reddish color of the ATTIC clay, a very thin wash of red ocher (*miltos*) was sometimes applied to the surface before the vase-painter started his work. When the wash had dried, it was BUR- NISHED, which helped it adhere to the vase. The vase was then ready for painting and firing. Often the underside of the foot was left unburnished, and, as a result, the color in that area may look less intense than the color of the rest of the vase.

Oinochoe (pl. OINOCHOAI)

Pitcher or jug; literally *oinochoe* (Gr. οἰνοχόη) means "wine-pourer" (Gr. οἶνος, wine, and χέω, to pour). Principally a server or ladle for wine, to judge by the many pictures on oinochoai depicting wine drinking or the wine god Dionysos and his companions, satyrs and maenads (see figs. 19, 26, 32).

The typical forms have been assigned numerical designations, and their chief characteristics are enumerated below. Shapes 1, 2, 3, and 5 are by far the most common: shapes 1 and 2 are popular in both black- and red-figure; most shape 3s are red-figure; most shape 5s black-figure. *Shape 1*: trefoil (three-spouted) mouth, offset neck, ovoid body. *Shape 2*: trefoil mouth, off- set neck, bulbous body. *Shape 3*: called a *chous* (Gr., χοῦς, pl. *choes*), which was its ancient name (see fig. 111): trefoil mouth, bulbous body continuously curved from neck to foot. The chous was associated particularly with the An- thesteria, an Athenian festival celebrating wine, the wine god Dionysos, and the dead. The festival's second day was called Choes. During the Anthesteria it was customary to drink from choes and to pour libations from them at the tomb. Miniature red-figured choes were decorated with pictures of children at play; some were festival presents to children, others undoubtedly gifts offered at a child's grave. The chous was a standard unit of measure, equiv- alent to about 3.28 liters (just under 3.5 quarts); twelve *kotylai* were in a chous, and twelve choes equaled one *metretes* (cf. PANATHENAIC AMPHORA). *Shape 4*: round mouth (also called flat mouth), otherwise similar to shape 2. *Shape 5*: called an *olpe* (Gr. ὄλπη, pl. *olpai*): a tall mug or tankard (see figs. 4, 60). The word is ancient but not necessarily applied correctly to this form. Early black-figured examples have a trefoil mouth, but the typical black- and red-figured olpe has a round mouth. *Shape 6*: narrow-beaked (narrow- spouted) mouth; neck and upper body concave, curved outward; lower body either straight-sided or concave, curved inward. *Shape 7*: wide-beaked mouth, offset neck, ovoid body. *Shape 8*: called a *mug*: closely resembles the modern one-handled mug, but often has two handles; it was used as a dipper for serv-

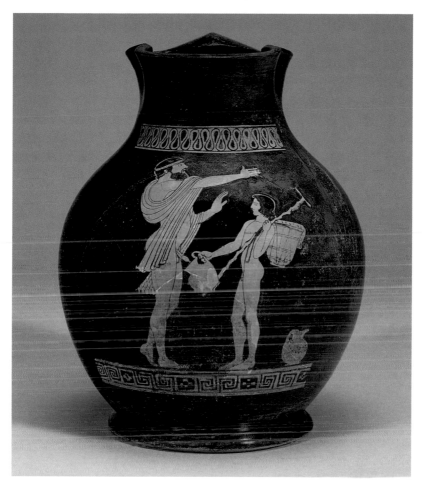

FIGURE 111. **OINOCHOE** (chous)
Drunken man urinating into an oinochoe held by a boy. Red-figured chous attributed to the
Oionokles Painter, about 470. H: 23 cm (9 in.). Malibu, JPGM 86.AE.237.

ing wine and a cup for drinking and measuring. *Shape 9*: round mouth, bulbous body continuously curved from neck to foot. *Shape 10*: narrow-beaked spout; body usually resembles shape 1. The *Cypro-jug* is a special form based on a narrow-beaked and round-bodied shape indigenous to Cyprus. For the hybrid shape *psykter-oinochoe*, see PSYKTER. FIGURES 4, 19, 26, 32, 60, 111, 139

OLPE See OINOCHOE, shape 5.

ONOS (pl. ONOI) See EPINETRON.

Oon (pl. Oa)

Small, very rare egg-shaped vase (Gr. ᾠόν, egg). Although the specific use of this shape, which occurs in both black- and red-figure, is unknown, real eggs as well as marble and ceramic ones were placed in graves. Oa with lids might have held a scented oil (perfume). It is hard to imagine that the lidless ones were containers at all, for they have either a small hole at one or both ends or no opening at all. FIGURE 112

FIGURE 112.
Oon
Paris abducting Helen. Red-figured oon attributed to an artist close to the ERETRIA PAINTER, about 440–410.
H: 5.1 cm (2 in.).
New York, MMA, Gift of Alastair B. Martin, 1971, 1971.258.3.

ORIENTALIZING

A phase in Greek art corresponding roughly to the seventh century B.C., when the mainland Greeks expanded trade and contacts far beyond the known world of the preceding GEOMETRIC period (900–720 B.C.) and came under the influences of the civilizations of the ancient Near East. The most momentous occurrence of this era was the adoption of the Phoenician alphabet by the Greeks, who used it to develop their own letter forms. Artistic stimulation also was profound, for the variety of animals, monsters, and exotic motifs brought a new visual vocabulary to the Greek Geometric artists and seem to have provided impetus to develop the first visual narratives in western art. In Athens the Orientalizing style is referred to as PROTOATTIC, in Corinth it is called PROTOCORINTHIAN. FIGURES 60, 61, 85, 124, 139

ORNAMENT

Linear patterns and floral designs that compliment both the shapes of vases and their pictures. Ornaments frequently serve as borders, but they may decorate large areas of a vase, sometimes occupying all the available space on the neck, under the handles, or below the picture. The history of some patterns can be traced to other Mediterranean cultures. Lotuses and palmettes, for example, originated in Egypt and first became known to the Greeks in the ORIENTALIZING period (seventh century B.C.) through the arts of the ancient Near East. Many of the designs on pottery may also be seen on metal vases,

textiles, and in architecture. It seems unlikely that the ornaments commonly found on Greek vases had symbolic meaning; ivy leaves are the exception— they are associated with the wine god Dionysos and often appear on vases used for serving wine. FIGURES 113, 114

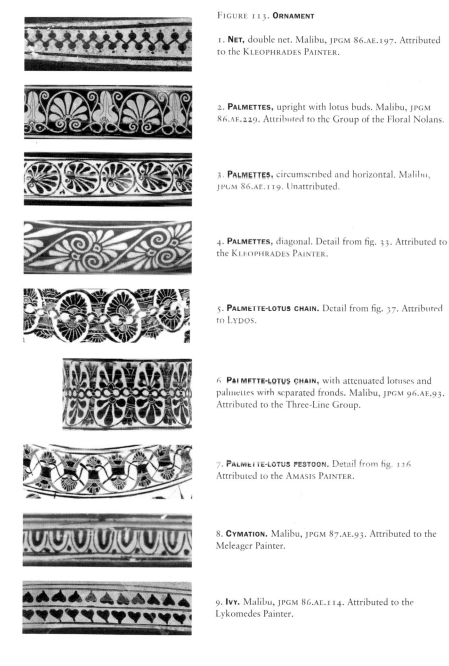

FIGURE 113. **ORNAMENT**

1. **NET,** double net. Malibu, JPGM 86.AE.197. Attributed to the KLEOPHRADES PAINTER.

2. **PALMETTES,** upright with lotus buds. Malibu, JPGM 86.AE.229. Attributed to the Group of the Floral Nolans.

3. **PALMETTES,** circumscribed and horizontal. Malibu, JPGM 86.AE.119. Unattributed.

4. **PALMETTES,** diagonal. Detail from fig. 33. Attributed to the KLEOPHRADES PAINTER.

5. **PALMETTE-LOTUS CHAIN.** Detail from fig. 37. Attributed to LYDOS.

6. **PALMETTE-LOTUS CHAIN,** with attenuated lotuses and palmettes with separated fronds. Malibu, JPGM 96.AE.93. Attributed to the Three-Line Group.

7. **PALMETTE-LOTUS FESTOON.** Detail from fig. 126 Attributed to the AMASIS PAINTER.

8. **CYMATION.** Malibu, JPGM 87.AE.93. Attributed to the Meleager Painter.

9. **IVY.** Malibu, JPGM 86.AE.114. Attributed to the Lykomedes Painter.

10. Ivy with corymboi. Detail from fig. 94. Attributed to a painter of the Vatican Class (Class M).

11. Laurel leaves with flower buds, flowers, or berries. Malibu, JPGM 80.AE.40. Attributed to the Patera Painter.

12. Upright lotus buds, open. Malibu, JPGM 96.AE.93. Attributed to the Three-Line Group.

13. Hanging lotus buds, open. Detail from fig. 39. Attributed to the Affecter.

14. Upright lotus buds, alternately open and closed. Malibu, JPGM 86.AE.85. Attributed to the Bareiss Painter, Medea Group.

15. Key (simple meander), running left. Malibu, JPGM 96.AE.93. Attributed to the Three-Line Group.

16. Broken key, running left. Malibu, JPGM 86.AE.227. Attributed to the Eucharides Painter.

17. Meander, running right. Detail from fig. 2. Attributed to the Brygos Painter.

18. Crossing meander (labyrinthine or swastika), running and enclosing saltire squares. Detail from fig. 115. Signed by Douris as painter.

19. Stopped meander, broken with checker squares. Malibu, JPGM 86.AE.289. Attributed to the Brygos Painter.

20. STOPPED MEANDER with cross-squares. Detail from fig. 26. Signed by DOURIS as painter.

21. RAYS. Malibu, JPGM 96.AE.93. Attributed to the Three-Line Group.

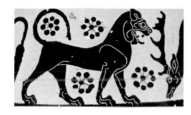

22. DOT ROSETTES. Detail from fig. 60. Attributed to the Painter of Malibu 85.AE.89.

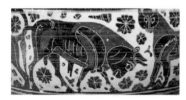

23. ROSETTES. Detail from fig. 75. Attributed to the Chimaera Painter.

24. TONGUES, enclosed. Detail from fig. 30. Attributed to the Painter of London B 174.

25. PALMETTE-LOTUS CROSS under handle, with **KEY MEANDER** running left, **UPRIGHT LOTUS BUDS,** and **RAYS** beneath. London, BM B 209. Attributed to EXEKIAS. Exekias's carefully composed ornament is in sharp contrast to the style of the MEIDIAS PAINTER (see fig. 114).

OUTLINE

Relatively wide black-GLOSS outline of a figural element on a red-figured
vase, often referred to as an *eighth-of-an-inch strip*. It was painted with a brush
after the preliminary design (today visible in a raking light) had been sketched.
It defines the contours of the images before the black background is painted.
The purpose of the eighth-of-an-inch strip was to prevent black gloss from
accidentally entering the RESERVED areas and possibly also to speed up the
painting process. FIGURE 115

OUTLINE PAINTING (OUTLINE DRAWING)

Outline painting is occasionally seen in black-figure—in lieu of ADDED
WHITE for women's skin, for example—and its use increases in red-figure; the
method is common on WHITE-GROUND. In contrast to the usual depiction of
figures against a black background, in outline painting they are "drawn" in
paint against the RESERVED or white ground, in a fashion similar to modern
drawing. FIGURES 18, 56, 66, 116

OXIDATION See FIRING, GLOSS.

PANATHENAIC AMPHORA

Large, narrow-necked pointed AMPHORA with small vertical handles, al-
ways decorated in black-figure technique (even long after the invention of
red-figure). Filled with olive oil from trees in Athena's sacred groves, the am-
phorae were awarded as prizes for victory in the Panathenaic games, a fes-
tival of sports held every four years in Athens to honor Athena, the city's
patron deity. The first Panathenaic prize vases were probably awarded in
566/565 B.C., when the Panathenaic games were reorganized; the amphorae

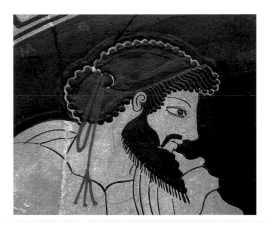

FIGURE 115.
OUTLINE
The crown of this
man's head and
his shoulder are
delineated by a thick
border of GLOSS; the
hair over his forehead
is painted with RELIEF
LINES. Detail of a
red-figured KYLIX
TONDO signed by
DOURIS as painter,
about 490. Malibu,
JPGM 83.AE.217.
Photo Maya Elston.

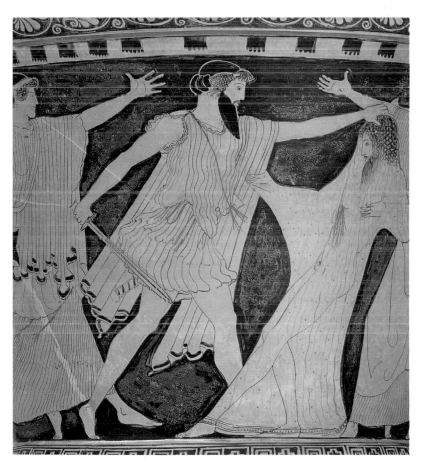

FIGURE 116. **OUTLINE PAINTING**
The nude figure of the dying Agamemnon (on the right), who has been caught in a net
by Klytaimnestra, is painted in outline against the RESERVED CLAY. Detail of a red-figured
calyx-KRATER attributed to the Dokimasia Painter, about 460. Boston, MFA 63.1246,
William Francis Warden Fund. Courtesy, MFA, Boston.

FIGURE 117. **PANATHENAIC PRIZE AMPHORA**

Athena. SIDE A of a Panathenaic prize amphora attributed to the Painter of the Wedding Procession,
signed by Nikodemos as potter, 363/362. INSCRIPTIONS identify the year and the special function of
the vase: "from the games at Athens." The boxers on SIDE B indicate the sport for which the
vase was awarded. H (with lid): 89.5 cm (35¼ in.). Malibu, JPGM 93.AE.55.

continued to be produced until the second century B.C. and, in very debased black-figure, well into the Roman era. As many as 140 amphorae are known to have been awarded to one winner for victory in a single contest.

Theoretically each vase held a *metretes* (the largest standard liquid measure), 39.39 liters (about 41.5 quarts, or more than 10 gallons; see also OINOCHOE, shape 3). Actual measurements have shown, however, that a typical prize amphora contained about three liters less than a metretes.

On the front of the vase Athena herself is always represented, and on the back, the contest for which the prize was won is (presumably) depicted. All Panathenaic prize amphorae are inscribed with the words "[a prize] from the games at Athens" (τῶν Ἀθήνηθεν ἄθλων). In the fourth century B.C. some Panathenaics were inscribed also with the name of the *archon* (chief magistrate) of Athens, which makes it possible to date them closely. Uninscribed vases of this shape—probably not prizes in most cases but, nevertheless, often decorated with Athena on one side—are known as *amphorae of Panathenaic shape* or *pseudo-Panathenaics*. FIGURE 117

PATTERN See EYES, MEANDER, ORNAMENT.

PELIKE (pl. PELIKAI)

Jar used principally for storage of liquids (especially oil and wine, as the pictures on pelikai themselves and as other shapes suggest) but, like the AMPHORA, also suitable for other commodities, wet or dry. From about 450 B.C. the pelike was used also as a container for the ashes of the dead. Very likely related to the AMPHORA Type C, the pelike is a wide-mouthed, pear-shaped vase (continuously curved from neck to foot) with two vertical handles; most are red-figured. The *neck-pelike*, a rare variation of the basic shape, has an offset neck and less globular proportions overall. In antiquity the name *pelike* (Gr. πελίκη) was applied to several vase forms, but not to the shape described here; its ancient name remains unknown. FIGURES 51, 96

PHIALE (pl. PHIALAI)

Shallow bowl for wine. In ceremonies or religious rites the phiale was used to pour libations to the gods; in other contexts, such as the symposium (male drinking party), it was just a drinking cup. The phiale (Gr. φῐάλη) resembles a plate; it has neither handles nor foot. In its most typical form it has a hollow knob in the middle—an omphalos (Gr. ὀμφᾰλός, navel)—projecting upward into the bowl, from which the type takes its name: the *phiale mesomphalos*, that is, with an omphalos in the center (Gr. μέσος, central).

The phiale was held with the middle finger tucked into the underside of the omphalos, and the thumb hooked over the rim (see fig. 32). The *phiale anomphalos* lacks the omphalos (Gr. prefix ἄν–, indicating absence). Many examples of gold, silver, and bronze phialai have been preserved; ceramic phialai, by contrast, are rare. FIGURES 118–19

PINAX (pl. PINAKES) See PLAQUE.

PLAQUE

Flat, rectangular slab (sometimes with rounded top); a decorated tile. The subjects represented on some plaques—funerary scenes or pictures of the gods—indicate that they adorned sanctuaries or tombs, where they were probably affixed to walls (either singly or in sets), as indicated by the holes (for nails) pierced through them. All the known examples of funerary plaques are in black-figure or early red-figure. Votive plaques, however—those with nonfunerary subjects—continue into late red-figure. *Pinax* (Gr. πίναξ, pl. *pinakes*) is another word used in modern times for this object—whose ancient name is unknown—but *pinax* actually denotes a painting on a wooden board, not a ceramic tile. FIGURE 120

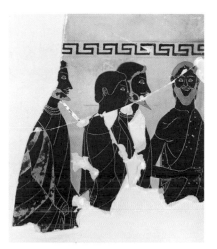

PLASTIC VASE

Vases partly in the shape of a small sculpture, most often a human or animal head or face; on occasion a complete figure. The term is derived from the German word *Plastik* (sculpture). The sculptural component was usually made in a two-part MOLD, but sometimes it was MODELED by hand. The vase's mouth and foot are usually wheelmade. We know a number of plastic vases by SOTADES, the BRYGOS PAINTER, and EUPHRONIOS, all of whom signed their work. See also ARYBALLOS, ASKOS, ASTRAGALOS, HEAD-VASE, KANTHAROS, and RHYTON. FIGURES 61, 93, 94, 110, 121, 135.

FIGURE 121.
PLASTIC VASE
Amazon mounted on
a horse; a ceremonial
drinking kylix
decorated in red-figure
makes up the vessel.
Signed by SOTADES
as potter, about
450–440. H: 34 cm
(13⅜ in.). Boston,
MFA Expedition,
21.2286. Courtesy,
MFA, Boston.
Reproduced with
permission. © 2000
MFA, Boston. All
rights reserved.

PLATE

Circular, flattish DISH with a raised rim; similar in size and shape to a modern dinner plate, but many are much smaller. Although common as an all-black vase or as a plain unglossed form, the plate is not often decorated in black- or red-figure technique; it is very likely that figured plates were not used for dining. Some have holes drilled in the rim, indicating that they were suspended for display; perhaps they were used in religious or funerary contexts. *Stemmed plates*, that is, plates with a foot not unlike a KYLIX, are popular in red-figure of the late fifth century B.C. See also FISH PLATE. FIGURES 27, 89

PLEMOCHOE (pl. PLEMOCHOAI) See EXALEIPTRON.

POLYCHROMY See COLOR.

POTTER See WORKSHOP.

POTTER'S WHEEL

Rotating device used for THROWING a CLAY vase. The clay is centered on the wheel and shaped by the potter's hands while the wheel rotates. The invention of the potter's wheel can be traced to the end of the fifth millennium B.C. in Mesopotamia.

How vases were formed on the wheel can be deduced by examining the vases themselves. The few Greek vases that illustrate the process show the

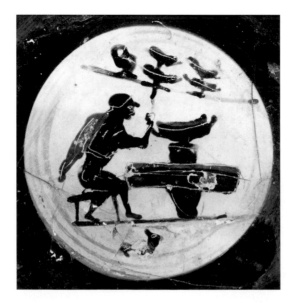

FIGURE 122.
POTTER'S WHEEL
Potter working at his wheel; completed pots rest on a shelf above him. Unattributed black-figured TONDO, about 530. London, BM B 432. © BM.

potter's wheel as a thick disk, two or three feet in diameter, with a socket in the center and a shaft sunk into the ground. Usually an assistant rotated the wheel, which left the potter free to work with both hands. See also CONSTRUCTION. FIGURES 76, 122

PRELIMINARY SKETCH

Design made by the vase-painter with a blunt tool or drawn with a piece of charcoal on the LEATHER-HARD surface of a vase to indicate the position of the figures or other details. Although painters may have worked out their pictures in drawings on surfaces other than the vase, it is significant that the preliminary sketches on the vases themselves show changes in outline and compositions—clear indication that at least some details were decided only as the vase was being painted. In most cases the preliminary sketch would be obscured by the black GLOSS or leave no traces on the surface. Sometimes, however, the painter pressed his tool into the clay hard enough to leave indentations that remained visible even after firing. FIGURE 123

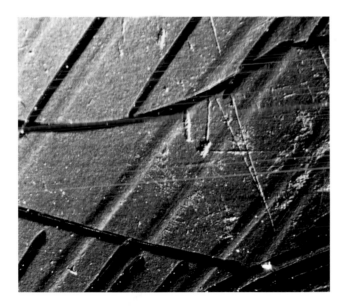

FIGURE 123,
PRELIMINARY SKETCH
Both preliminary
sketch lines
(indentations) and
RELIEF LINES in GLOSS
are clearly visible on
this enlarged detail of
a red-figured TONDO.
Photo Maya Elston.

PROTOATTIC

Approximately contemporary with PROTOCORINTHIAN vase-painting (about 720–620 B.C.), Protoattic is synonymous with the ORIENTALIZING period in Athens, which preceded the development of BLACK-FIGURE TECHNIQUE there. Linear OUTLINE, embellished with ADDED WHITE, minimal INCISION, and

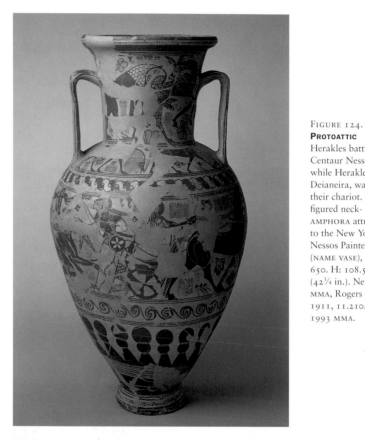

FIGURE 124.
PROTOATTIC
Herakles battling the
Centaur Nessos,
while Herakles' wife,
Deianeira, waits in
their chariot. Black-
figured neck-
AMPHORA attributed
to the New York
Nessos Painter
(NAME VASE), about
650. H: 108.5 cm
(42¾ in.). New York,
MMA, Rogers Fund,
1911, 11.210.1. ©
1993 MMA.

silhouette, is used to describe visions—often both lively and expressive—of monsters and motifs inspired by Oriental prototypes and fused to early stories from Greek myth and legend. FIGURE 124

PROTOCORINTHIAN

The Protocorinthian period (about 720–620 B.C.)—the ORIENTALIZING precursor of CORINTHIAN pottery—is roughly contemporary with the PROTOATTIC style in Athens. The hallmark of the style is a repetitive decorative miniaturism, and its most common shape is the ARYBALLOS. BLACK-FIGURE TECHNIQUE, executed with highly developed skills of INCISION and POLYCHROMY, was first developed in Corinth during this period. The lively appearance of Protocorinthian pottery is heavily indebted to influences from the Orient for both subject matter (the ANIMAL STYLE, for example) and ORNAMENT, especially the rosette, which is by far the most common motif of both Protocorinthian and Corinthian design. FIGURE 60

PROTOME (pl. PROTOMAI or PROTOMES)

Commonly a moldmade component of a PLASTIC VASE such as a RHYTON or a KANTHAROS, but also an embellishment on other shapes, for example, as adjunct elements of the handles or mouth of a shoulder-HYDRIA. Protomes take the shape of the forepart of an animal (head, chest, and forelegs) or the head and upper body of a person. Drawings of protomes show up frequently in vase-painting as shield devices. FIGURES 125, 126

FIGURE 125.
PROTOME
Lion protome, from Crete. This moldmade piece was probably originally attached to a terracotta dedicatory shield. Diam: 7.0 cm (2¼ in.). Malibu, JPGM 91.AD.24.

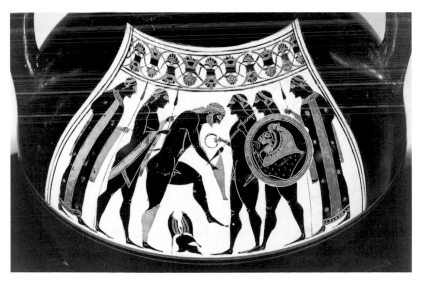

FIGURE 126. **PROTOME**
Depiction of a lion protome adds ferocity to the shield of a *hoplite* (foot soldier). Detail of black-figured AMPHORA attributed to the AMASIS PAINTER, about 550–540. New York, MMA, Rogers Fund, 1906, 06.1021.69.

Psykter (pl. PSYKTERS or PSYKTERES)

Mushroom-shaped vase used as a wine cooler, either lidless and without handles or with a lid fitted to a flanged mouth and small tubes on the shoulder to accommodate strings for carrying the vase or, possibly, tying on the lid. The name *psykter* (Gr. ψυκτήρ) is ancient, surely derived from the function of the vase (Gr. ψύχω, to cool). *Psykter* seems also to have been a general term for a wine cooler and, presumably, it was applied to other shapes as well.

The psykter was introduced after the invention of red-figure and, therefore, most are red-figured. Its peculiar form allowed the psykter to float in a KRATER—the stem acting like the keel of a boat—but it could stand firmly on its base, too. Vase-paintings imply that the psykter held the wine (unmixed on occasion), and that the krater held the cooling agent, either cold water or snow. Some scholars contend that the psykter held the coolant; however, if this were so, the surrounding wine would chill more slowly: a disadvantage that makes it doubtful that this would have been normal practice. Almost certainly, therefore, the cool wine was ladled from the psykter into an OINOCHOE or a KYLIX. When disturbed by a ladle as it floated in a krater, the psykter must have bobbed and turned so that all sides could be seen. Taking this into account, the vase-painter did not frame the pictures on a psykter in separate panels: The images continue uninterrupted around the vase.

Several rare hybrids of the psykter are known. A *krater-psykter* permanently combines the functions of a krater and a psykter, either by implanting a psykter inside the bowl, or by making the krater's body double-walled which, when the compartment between the two walls was filled with cold water, chilled the wine. The *amphora-psykter* worked like a double-walled krater; most examples are neck-amphorae. A *psykter-oinochoe* is a psykter with a trefoil mouth instead of a round one and a vertical handle for pouring (this vase definitely contained wine rather than coolant). FIGURE 127

Purification of clay See CLAY.

Pyxis (pl. PYXIDES)

Small cylindrical box with a lid; it served as a container for cosmetics such as rouge, for incense or jewelry, or for medicinal ointments; vase-paintings show women with pyxides. *Pyxis* (Gr. πυξίς) was probably a generic ancient term for box, which, more specifically, could mean a box made of boxwood (Gr. πύξος). It is probable that the ancient ATTIC name of the pyxis actually

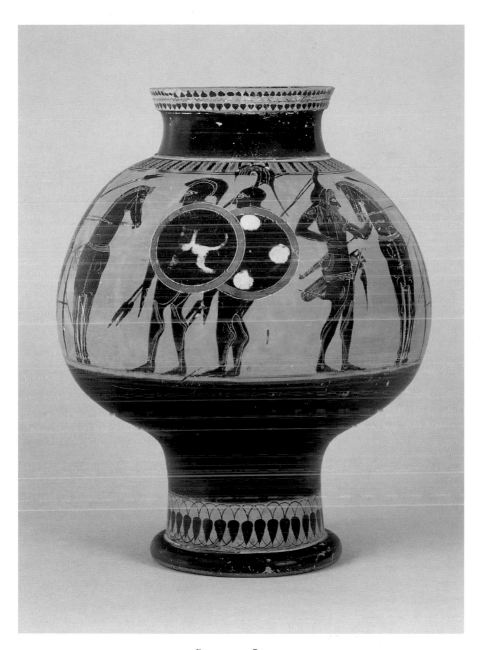

FIGURE 127. **PSYKTER**

Hoplites (foot soldiers), Scythian archers, and their mounts. Black-figured psykter attributed to the
LYSIPPIDES PAINTER, about 540–530. H: 33 cm (13 in.). Malibu, JPGM 96.AE.94.

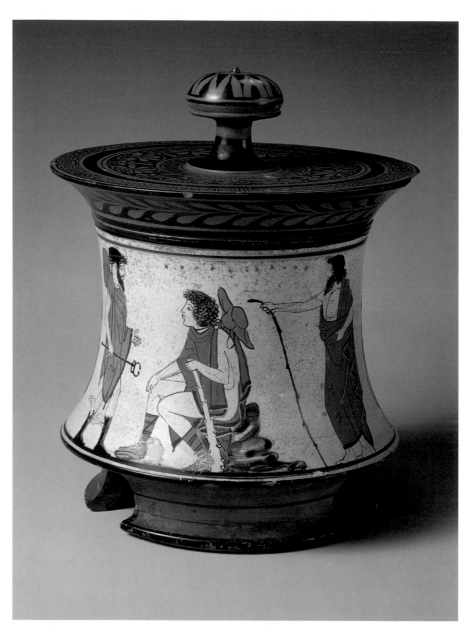

Judgment of Paris; Hermes (on the left) talking with the seated Paris. WHITE-GROUND pyxis (Type A)
attributed to the PENTHESILEA PAINTER, about 470. H (with lid): 17.2 cm (6¾ in.). New York,
MMA, Rogers Fund, 1907, 07.286.36. © 2001 MMA.

was *kylichnis* (Gr. κῠλιχνῐ́ς, pl. *kylichnides*), although it is not known to what specific type of pyxis this might have applied.

The following are the principal forms of pyxides. *Type A* (see fig. 128): flat lid with knob, concave-sided body, ringlike foot (sometimes divided into three or four sections) or footless. *Type B*: a low, wide shape (resembling a modern powder box), straight-sided body, slip-over lid. *Type C*: in red-figure only, convex lid, concave-sided body like Type A but shallower and broader. *Type D*: sometimes called a box-pyxis; in red-figure only, body similar to Type B but smaller, caplike lid rather than slip-over. *Nikosthenic pyxis* (named after the potter NIKOSTHENES): domed lid with finial, body shaped like an inverted bell set on a short stem, and supported by a flaring foot. *Tripod-pyxis* (also known as a *tripod-kothon*): lid with finial, bowl-shaped body supported on three concave, slablike legs. FIGURE 128

RAISED (EXTRUDED) DOTS AND LINES

Relief dots and lines used for details such as hair (to give the illusion of curls), ornaments on garments, grapes, or other decorative elements of the design. CLAY SLIP or GLOSS was probably extruded from a special tool or perhaps made with a brush to create the desired pattern. If the dots were made of clay, they might be painted with black gloss, GILDED, or left RESERVED. FIGURE 129

FIGURE 129.
RAISED DOTS
Raised dots form the hair and beard of Herakles. Detail of red-figured AMPHORA attributed to the BERLIN PAINTER, about 490–480. Basel, Antikenmuseum und Sammlung Ludwig BS 456. Photo Claire Niggli.

Around 530 B.C. in the KERAMEIKOS, a new technique came into being that revolutionized vase-painting: red-figure. Its invention has often been credited to the ANDOKIDES PAINTER. Those vase-painters who developed red-figure technique, and who were the first to explore the full range of its possibilities, are known as the PIONEERS. The older technique, BLACK-FIGURE, continued side-by-side with red-figure (see BILINGUAL), but by about 470 B.C. black-figure vases of significant artistry were no longer being produced, with the important exception of PANATHENAIC AMPHORAE.

In red-figure technique, the background is painted black, and the figures and ornaments stand out as RESERVED orange-red spaces in which the details are *painted* in black lines (fig. 130; see RELIEF LINE); this technique offers the painter much greater freedom of expression than had been possible with the INCISED lines of black-figure.

FIGURE 130. **RED-FIGURE**
The goddess Eos. In contrast to the INCISION typically used in black-figure, in red-figure the use of a brush for details gave the painters enhanced drawing capability. Detail of the exterior of a KYLIX signed by DOURIS as painter, about 480. Malibu, JPGM 84.AE.569.

The red-figure technique was executed as follows. After the vase was shaped, it was BURNISHED. (OCHER was sometimes applied to the surface before burnishing; during FIRING the ocher turned deep reddish-orange, thus intensifying the natural color of the ATTIC clay.) After burnishing, a PRELIMINARY SKETCH was made directly on the surface of the vase. First the figures and ornaments were OUTLINED with black GLOSS, and then details were carefully painted in gloss, DILUTE GLOSS, and relief lines. ADDED COLORS were also applied before firing, but in contrast to black-figure, their use in red-figure was very limited; both male and female skin was left RESERVED in red-figure, in striking contrast to black-figure, where female skin was usually painted in added white. See also FIRING. FIGURES 1, 2, 3, 6, 7, 8, 9, 11, 12, 14, 16, 17, 21, 22, 23, 25, 26, 27, 28, 32, 33, 38, 40, 41, 42, 44, 45, 46, 47, 48, 51, 52–53, 58, 62–63, 64, 69, 74, 77, 80, 84, 88, 89, 93, 99, 101, 102, 104, 106, 110, 111, 112, 114, 115, 116, 118–19, 121, 123, 129, 130, 131, 135, 137, 140

REDUCTION See FIRING, GLOSS.

FIGURE 131.
RELIEF LINE
Black-GLOSS relief line is used for the curls of the hair of the goddess Thetis and to delineate her facial features. Detail of fragmentary red-figured STAMNOS attributed to the KLEOPHRADES PAINTER, about 470. Malibu, JPGM 82.AE.87. Photo Maya Elston.

RELIEF LINE

Line painted on a vase with GLOSS so thick that it leaves a visibly raised line. The gloss used for relief lines is made from a thicker version of the fine CLAY SLIP that was used to paint the backgrounds on red-figured vases (cf. DILUTE GLOSS). Relief lines were used either to OUTLINE figures against the background or to delineate certain details of a drawing, such as clothing or locks of hair. Relief lines were a hallmark of red-figure painting. FIGURES 115, 123, 131

REOXIDATION See FIRING, GLOSS.

It was common practice in antiquity to repair damaged objects. Greek ceramics offer many examples of vases with bodies, handles, or feet that were mended in antiquity to prolong their life. The use of repaired vases, however, perhaps differed from their original purposes—if they were initially made to hold liquids, for instance, after mending they might be used mainly for dry goods.

A common way to repair adjoining parts was to make a pair of holes with a small bow- or palm-drill on opposite sides of the break. The two parts could then be held together with pieces of metal, either lead or bronze, which are referred to variously as pins, wires, staples, rivets, or clamps, depending on their shape and manner of application. These pins were often installed through the holes, but sometimes lead was cast in place to assure structural support. Clamps may also have been inserted into channels or grooves, chiseled to accommodate the length of the metal section. Sometimes the repair was later disguised, but at other times it rested directly on the surface of the vase. Occasionally, metal sleeves or plates were inserted into the hollow interior of a foot (see figs. 133, 134). Such metal components, though corroded, still remain in place on some vases. Most of the ancient repair work consists of joining fragments from the same vase, but there are also examples of vases that were repaired using parts from other vases (see ALIEN, fig. 58). Although there is no evidence that any glue was used in conjunction with the metal pins—the ancient restorer apparently relied on the structural integrity of the mechanical joins—adhesives such as pine pitch or other resins were perhaps applied to seal the joins. It appears that when an object was considered important for aesthetic or ritual reasons, the ancient craftsman took great care to make the repair unobtrusive. FIGURES 30, 58, 132, 133, 134

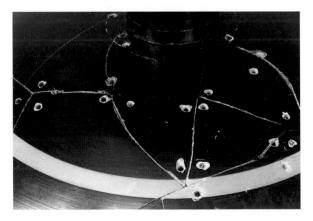

FIGURE 132.
REPAIR
Numerous drill holes perforate the interior of this KYLIX; they were made in antiquity to receive the small metal pins or wires (now long lost) typically used to hold together broken pieces of pottery. Detail of LITTLE-MASTER band-cup, about 530–520. Malibu, JPGM 77.AE.50. Photo Maya Elston.

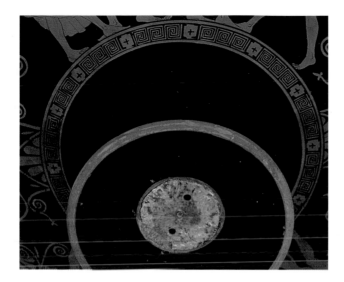

FIGURE 133.
REPAIR
The ancient bronze
disk under the foot
of this KYLIX was
used in antiquity to
strengthen a broken
stem. Detail of red-
figured kylix
attributed to the
Euaion Painter, about
450–440. Malibu,
JPGM 86.AE.682.
Photo Maya Elston.

bronze pin

bronze disk

metal plate seen in side view

FIGURE 134.
REPAIR
X-ray showing a
detail of the repair in
fig. 133. In addition
to the disk, a bronze
plate (seen in side
view) and a pin held
the plate in place.
Photo Antiquities
Conservation
Department, JPGM.

RESERVED AREA

The part of the surface of a vase to which GLOSS was not applied is called *re-served*. The reddish-orange color typical of ATTIC Greek vases is the color of the reserved surface of the fired clay (see FIRING), often enhanced with an OCHER wash. In black-figure, the reserved area is the background for the painted figures and ornament (see BLACK-FIGURE TECHNIQUE); in red-figure, it is the reverse: The figures and ornament are reserved areas against the painted black-gloss background (see RED-FIGURE TECHNIQUE).

RETROGRADE See INSCRIPTIONS.

RHYTON (pl. RHYTA)

One-handled drinking cup; a PLASTIC VASE with a moldmade lower part, generally in the shape of an animal's head, and a cup-shaped upper part that is wheelmade. The vase, originally based on EAST GREEK or Persian metal rhyta, is conventionally but misleadingly called a drinking horn: most ceramic rhyta do not resemble a true drinking horn—in the shape of an animal's curved horn—for which the Greek word was *keras* (Gr. κέρας). In antiquity the derivation of *rhyton* (Gr. ῥυτόν) was connected with a word meaning "flowing through like a stream" (Gr. ῥύσις). In fact this accords well with a feature typical of *metal rhyta*: they have a hole at the lower end, out of which the wine flows in a thin stream. Most ceramic rhyta lack this feature; their ancient name is not known.

A red-figured vase, the rhyton uses many different animals' heads for its shape: bird, boar, bull, cow, deer, donkey, eagle, fawn, goat, greyhound, griffin, horse (or horse with rider), hound, lamb, lion, pig, ram, or sphinx. Sometimes a half head of a ram is joined with a half head of a boar or donkey, forming a so-called *dimidiating rhyton*. The human subjects are few; because they are so sculptural, these rhyta are better described, perhaps, as statuette vases: a mounted Amazon (see fig. 121), an Ethiopian, a youth attacked by a crocodile, a grotesque head of an old man, and a pygmy fighting a crane. FIGURES 121, 135

FIGURE 135.
RHYTON
Donkey rhyton with satyrs cavorting on the exterior of the bowl. Red-figured rhyton attributed to the BRYGOS PAINTER, about 480. L: 25.4 cm (10 in.). Boston, MFA, Francis Bartlett donation of 1900, 1903, 03.787. Courtesy, MFA, Boston. Reproduced with permission. © 2000 MFA, Boston. All rights reserved.

SIDES A, B

The obverse, or main, side (front) of any shape with two handles is conventionally known as *A*, and in general this is the side with the more important subject or more complex image; the reverse (back) is called Side *B*.

SIGNATURES

POTTERS and painters sometimes wrote their names on vases, though why certain pieces were selected for signature is not known; at times the lesser efforts of a painter were signed, while finer vases were not. Potters signed vases about twice as often as painters, but why this should be so is not understood; the vast majority of all vases are unsigned (see ARTISTS' NAMES). Signatures on vases are our only sources for the ancient names of potters and painters, for unlike the names of Greek architects, sculptors, and mural painters, which are well attested in ancient literature, not even one potter's or vase-painter's name is mentioned in those texts.

There are three types of signatures, each composed of a name and a verb (or verbs), and sometimes expressed as if the vase itself were speaking: "so-and-so *made* [me]" (Gr. *epoiesen* [ἐποίεσεν], meaning *made*; see fig. 4); "so-and-so *painted* [me]" (Gr. *egraphsen* [ἔγραφσεν], meaning *wrote* or *drew*, but also *painted*; see fig. 27); and "so-and-so *painted and made* [me]" (Gr. *egraphse kapoiese* [ἔγραφσε κἀποίεσε]). Sometimes separate *epoiesen* and *egraphsen* INSCRIPTIONS appear on one vase, each verb with a different name—the signatures of two individuals. In general the *epoiesen* signature is taken to be the potter's, *egraphsen* the painter's, and *egraphse kapoiese* the signature of the exceptional craftsman such as EXEKIAS who, at times, both painted and potted a vase. Occasionally an artist not only signs his own name but also gives his father's as part of the signature: "so-and-so, the son of . . ."

Signatures, however, are not without their uncertainties. *Epoiesen* does mean *made*, but the word has a very broad meaning in Greek. The *epoiesen* signature could mean that the potter made it with his own hands, or it might have meant that the man named was, perhaps, the owner of the WORKSHOP, but not necessarily the maker of the signed vase. In other words, the *epoiesen* signature might have been a brand or trade name. It is presumed that the painter wrote the *egraphsen* signatures, but who inscribed the *epoiesen* signatures? Very likely it was the painter, too. Nevertheless, even if these questions were settled, the fact remains that, except for their names, little else is likely ever to be known about these craftsmen as individuals. FIGURES 3, 4, 27, 29, 55, 56

SILHOUETTE See BLACK-FIGURE TECHNIQUE.

SINTERING

Fusion of the edges of microscopic particles of CLAY that occurs during FIR-ING just before the particles melt into a glaze. Only partial sintering occurred, however, in the firing of Greek vases, which does not produce a true (fully fused, vitrified) glaze, but rather GLOSS. See also FIRING.

SIX'S TECHNIQUE

POLYCHROME technique invented around 530 B.C., possibly in the WORK-SHOP of NIKOSTHENES. Before FIRING, the picture is painted in ADDED COL-ORS—mostly white, plus red and pink—over the black GLOSS surface of the vase; after painting, the picture is refined with INCISIONS. BEAZLEY called this "Six's technique" in recognition of the Dutch scholar Jan Six, who first drew attention to these polychrome vases. FIGURE 136

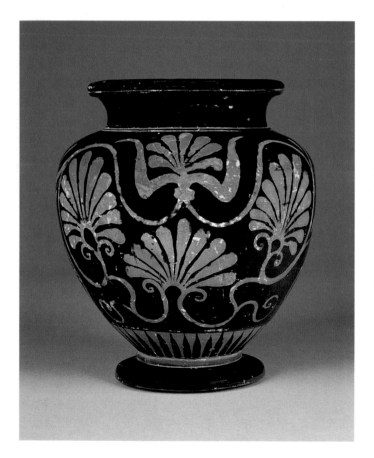

FIGURE 136.
SIX'S TECHNIQUE
Dark-red palmettes painted in Six's technique on top of the black gloss. Handleless STAMNOS, end of the sixth century. H: 20.7 cm (8⅛ in.). Malibu, JPGM 83.AE.324.

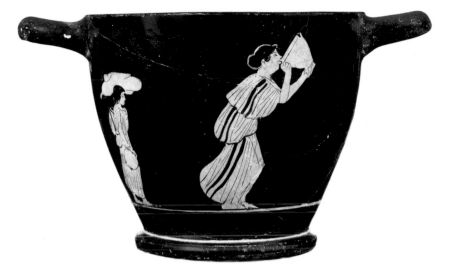

FIGURE 137. **SKYPHOS**
Woman drinking heartily from a large skyphos similar in shape to the one upon which she is painted.
Unattributed red figured skyphos (Type A), about 470–460. H: 15.3 cm (6 in.). Malibu,
JPGM 86.AE.265.

SKYPHOS (pl. SKYPHOI)

Deep drinking cup with two handles, usually but not always horizontal, at or near the level of the rim. It is possible that *skyphos* (Gr. σκύφος) could be the ancient name of the shape described here. In all-black or unglossed plain wares the skyphos was the most common type of cup, more popular than even the KYLIX. *Kotyle* (Gr. κοτύλη, pl. *kotylai*) or *kotylos* (Gr. κότυλος, pl. *kotyloi*) are other names sometimes applied to this form. Apparently *kotylos* was another word for KANTHAROS. *Kotyle* was also the name of a standard unit of measure, equivalent to about 0.27 liters (about ½ pint); twelve kotylai equaled one *chous* (see OINOCHOE, shape 3), another standard measure.

The basic forms of the figured skyphos are the following. *Corinthian type*: thin-walled cup with delicate handles and a ring foot; the form originated in CORINTH. *Type A* (or ATTIC type): relatively thick-walled with sturdy handles and a torus (tire-shaped) foot; overall proportions heavier than the Corinthian type. *Type B*: easily distinguished by its disparate handles—one horizontal and one vertical—body similar to Type A but the lower body more tapered and the foot smaller; the type is very common in red-figure, almost invariably decorated with an owl, and accordingly often called an *owl-skyphos*, or a *glaux* (Gr. γλαύξ, owl). The *cup-skyphos* is a hybrid, as the name implies: like a skyphos the bowl is deep, but like a kylix its handles are upcurved and the bowl tapers sharply toward the foot. FIGURE 137

SLIP

Uniform blend of very finely LEVIGATED CLAY and water mixed to a creamy consistency. Slip is used to join separately made sections of a vase or to coat some vases by brushing or pouring it on the surface. White slip was applied to the outside of some vases, mainly LEKYTHOI (see WHITE-GROUND), which were used for funerary rituals. The white slip provided an excellent surface for painting and decorating the vase. Slip was used also for making the black GLOSS on Greek vases (see FIRING, RELIEF LINE).

SME(G)MATOTHEKE (pl. SME[G]MATOTHEKAI) See EXALEIPTRON.

STAMNOS (pl. STAMNOI)

Wide-mouthed jar, often lidded, with offset neck and usually two horizontal handles. As depicted on vases, the *stamnos* (Gr. στάμνος) was used like a KRATER for mixing wine and water. The canonical shape was introduced after the invention of red-figure, and consequently most stamnoi are red-figured. Like an AMPHORA this vase probably served as a general storage jar for liquids and small foodstuffs. In addition, stamnoi served as containers for money, ballot boxes, and cremation ash urns. It seems likely, however, that *stamnos* was another ancient name for amphora, and not the name of the shape described here. FIGURES 25, 32, 136

TERRACOTTA

FIRED CLAY, literally, "baked earth" (Italian).

THROWING

Giving a vase its general shape by using a POTTER'S WHEEL to form the CLAY. To throw a vase, the desired amount of clay is centered on the rotating wheel. While the wheel rotates, the potter pulls up the clay and forms it to the desired shape. The vase is then cut off the wheel by pulling a wire or cord through the base, and the vase is set aside to dry and harden. Some Greek vases were thrown in one piece, but many common shapes—AMPHORAE, KYLIKES, and KRATERS, for example—were thrown in several sections that were later joined with clay SLIP. See also CONSTRUCTION, TURNING. FIGURES 76, 122

TONDO (pl. TONDI)

The circular picture on the inside of a KYLIX or PLATE is called a *tondo* (Italian, round or circular); in the literature it is designated by the letter *I* (for inside or interior). FIGURES 2, 6, 9, 26, 27, 48, 69, 122

TOOLS AND TOOL MARKS

Instruments required for the production of vases and the marks (some of them intentional) left by them on the surface of the vases. A variety of tools have been employed in the production of the vases such as: sticks; cutting and shaping knives made of wood, metal, or bone; measuring tools such as rulers and calipers; compasses; brushes in various thicknesses; and sponges and bowls with slip. The traces and marks left on the surfaces of vases provide evidence of the use of such tools, as do some illustrations on Greek vases showing their application. It is presumed that many of the tools used by modern potters are similar to those used by ancient Greek potters. FIGURES 87, 123, 140

TRADEMARKS

Single or linked letters, numbers, and other marks were sometimes painted (DIPINTI) in red OCHER or black GLOSS or INCISED (GRAFFITI) under the foot of a vase. Red ocher and incised marks were added after FIRING, while those in black gloss were made before firing. Some so-called trademarks denote prices and quantities, a few are the names of vases, but the significance of the majority of these marks is not understood. FIGURES 83, 92

TRIPOD-KOTHON (pl. TRIPOD-KOTHONES) and **TRIPOD-PYXIS** (pl. TRIPOD-PYXIDES) See PYXIS.

TURNING

The process of trimming and removing superfluous or uneven CLAY in order to refine the shape of a vase or reduce the thickness of its walls after it has been THROWN. When the vase had dried to a LEATHER HARD state, it was centered on the wheel again if the shape had to be refined. While the vase rotated, various TOOLS made of wood, metal, or bone were used to trim and refine the shape by removing extra clay and smoothing the surface with a wet sponge or leather. Details such as grooves would be made at this stage. If the vase had been made in sections, they were now joined with SLIP, and the whole vase was turned on the wheel. On vases such as KYLIKES and KRATERS, where both the interior and exterior are visible, both surfaces were carefully turned and smoothed. In contrast, on vases with narrow openings, such as AMPHORAE, HYDRIAI, and PELIKAI, only the exterior was turned. Marks left by the potter's fingers (throwing marks) are often visible on the unturned interiors of such vases. See also CONSTRUCTION, THROWING, LEATHER-HARD.

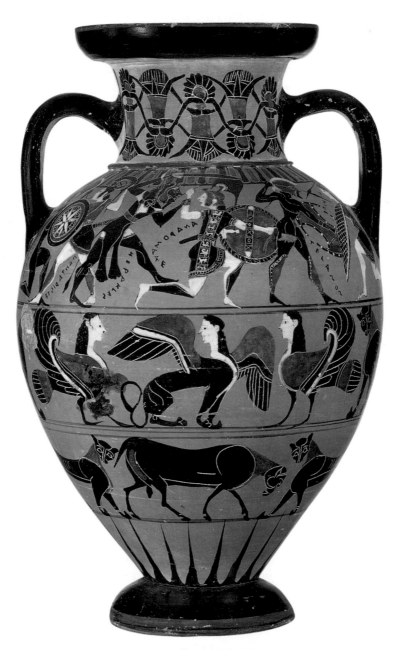

TYRRHENIAN AMPHORA

Distinctively ovoid-shaped black-figured ATTIC neck-AMPHORA, produced around 570–550 B.C., apparently especially for export to Etruria in Central Italy, where nearly all of them have been found. The vases were fashioned for a market already in tune with CORINTHIAN style; their unstinting use of ADDED COLORS and decorative animal friezes come from that tradition. *Komasts* (dancers) and the adventures of Herakles are among the most popular subjects on Tyrrhenian vases. The artists to whom these amphorae (and a few examples of other shapes) are ATTRIBUTED are known as the *Tyrrhenian Group*. FIGURE 138

WEDGING OR KNEADING

Cutting, beating, and working the CLAY in order to make it more homogeneous; even consistency is essential to successful CONSTRUCTION of a vase. In antiquity these operations were executed by hand (today they are done by machine). Wedging, the first step in the process of constructing a vase, removes air bubbles, thereby improving the working properties of the clay. When wedging is completed, the clay is ready to be THROWN.

WHITE-GROUND

A SLIP of fine white CLAY applied to the surface of a vase before painting the image or design. The white then formed the background for the image, which was either painted in black-figure technique, OUTLINED, or outlined with POLYCHROMY. This technique—called white-ground—was used mainly on LEKYTHOI and on some KYLIKES and KRATERS. FIGURES 18, 49, 50, 56, 57, 66, 128

WILD-GOAT STYLE

The Wild-Goat Style, produced approximately 650–550 B.C., is characteristic of pottery made in EAST GREECE, especially at the sites of Chios, Miletos, and Rhodes. The name is derived from its principal decoration: friezes of goats (and sometimes other animals, such as deer) that circumnavigate the pot in a lazy procession of grazing poses (see ANIMAL STYLE). A wide variety of motifs is used for filling, most derived from ORIENTALIZING sources. The painting style is typified by dark patterning applied on the pale SLIP covering the local CLAY. FIGURE 139

FIGURE 139. **WILD-GOAT STYLE**
Friezes of grazing wild goats from an ORIENTALIZING WORKSHOP of EAST GREECE. OINOCHOE,
probably from Miletos, about 625. H: 35.7 cm (14 in.). Malibu, JPGM 81.AE.83.

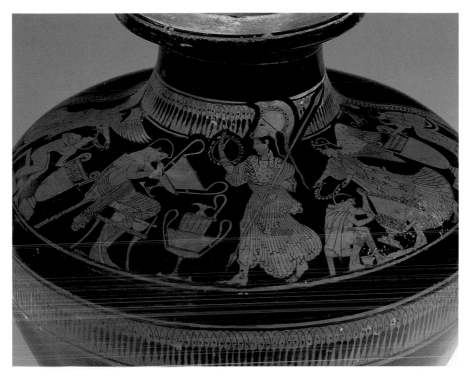

FIGURE 140. **POTTER'S WORKSHOP**
Athena crowns the staff of a potter's workshop. Shoulder of red-figured HYDRIA (kalpis) attributed to
the Leningrad Painter, about 490–480. Vicenza, Banca Intesa Collection C 278

WORKSHOP

Term referring both to the working space where vases were made and to
stylistically related GROUPS of potters and painters (for example, the work-
shop of the PENTHESILEA PAINTER). The workshops and their owners were
the economic foundations of ceramic production. Whereas painters seem to
have moved from one workshop to another, potters (and potter-painters)
were stable, determining production, workforce, and clientele (see especially
AMASIS, EXEKIAS, EUPHRONIOS, NIKOSTHENES, and SOTADES) in what was
most likely a family-run business. From four to a dozen skilled persons
were employed in a workshop, engaged in digging and PURIFYING the CLAY,
WEDGING, THROWING the vases on the POTTER'S WHEEL, TURNING, paint-
ing, FIRING, and selling the vases. Athens and Corinth both had potters'
quarters (see KERAMEIKOS), where the majority of workshops were located.
FIGURES 9, 69, 76, 122, 140

WRITING See DIPINTI, GRAFFITI, INSCRIPTIONS, SIGNATURES, TRADEMARKS.

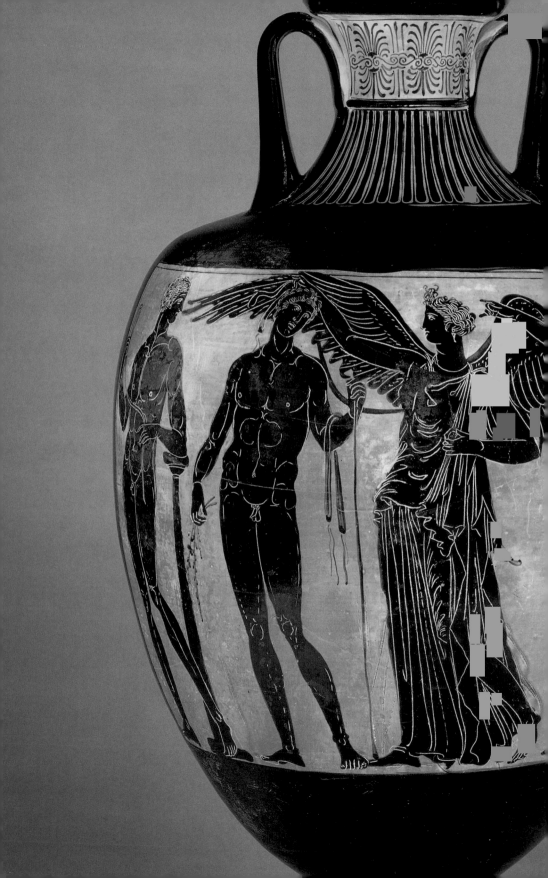

Select Bibliography

AMYX, D. A. *Corinthian Vase-Painting of the Archaic Period*. Berkeley, 1988.

ARIAS, P. E., and M. HIRMER. *A History of a Thousand Years of Greek Vase Painting*. Trans. and rev. by B. Shefton. New York, 1962.

BEAZLEY, J. D. *The Development of Attic Black-figure* (= *Dev.*). 1951. Rev. edn., D. von Bothmer and M. B. Moore, eds. Berkeley, 1986.

———. *Attic Black-figure Vase-painters* (– *ABV*). 1956. Reprint, New York, 1978.

———. *Attic Red-figure Vase-painters*. 2nd edn. (= *ARV²*). 1963. Reprint, New York, 1984.

———. *Paralipomena: Additions to ABV and ARV²* (= *Para.*). Oxford, 1971.

BOARDMAN, J. *Athenian Black Figure Vases*. New York, 1974.

———. *Athenian Red Figure Vases: The Archaic Period*. New York, 1975.

———. *Athenian Red Figure Vases: The Classical Period*. New York, 1989.

———. *Early Greek Vase Painting: Eleventh–Sixth Centuries B.C.* London, 1998.

———. *The History of Greek Vases: Potters, Painters and Pictures*. London, 2001.

BUYS, S., and V. OAKLEY. *The Conservation and Restoration of Ceramics*. Oxford, 1993. Reprint 1998.

CARPENTER, T. H. *Art and Myth in Ancient Greece*. London, 1991.

———. *Beazley Addenda: Additional References to ABV, ARV² and Paralipomena*. 2nd edn. New York, 1989.

COOK, R. M. *Greek Painted Pottery*. 3rd edn. New York, 1997.

———, and P. DUPONT. *East Greek Pottery*. New York, 1998.

FURTWÄNGLER, A., and K. REICHHOLD. *Griechische Vasenmalerei: Auswahl hervorragender Vasenbilder*. Munich, 1904–1932.

Lexicon Iconographicum Mythologiae Classicae. 8 vols. Zurich, 1981–1997.

NEEFT, C. W. *Addenda et Corrigenda to D. A. Amyx, Corinthian Vase-Painting in the Archaic Period*. Amsterdam, 1991.

NOBLE, J. V. *The Techniques of Painted Attic Pottery*. Rev. edn. New York, 1988.

RASMUSSEN, T., and N. SPIVEY, eds. *Looking at Greek Vases*. Cambridge, 1991.

ROBERTSON, M. *The Art of Vase-painting in Classical Athens*. Cambridge, 1992.

———. *Greek Painting*. Geneva, 1959.

SCHEFOLD, K. *Gods and Heroes in Late Archaic Greek Art*. Cambridge, 1992.

———. *Myth and Legend in Early Greek Art*. New York, 1966.

SCHREIBER, T. *Athenian Vase Construction*. Malibu, 1999.

SIMON, E., and M. HIRMER, *Die Griechischen Vasen*. Munich, 1976.

SPARKES, B. A. *Greek Pottery: An Introduction*. New York, 1991.

———. *The Red and the Black: Studies in Greek Pottery*. New York, 1996.

STIBBE, C. M. *Lakonische Vasenmaler des sechsten Jahrhunderts v. Chr*. Amsterdam, 1972.

TRENDALL, A. D. *Red Figure Vases of South Italy and Sicily: A Handbook*. London, 1989.

WILLIAMS, D. *Greek Vases*. 2nd edn. London, 1999.

Chart of Vase Shapes

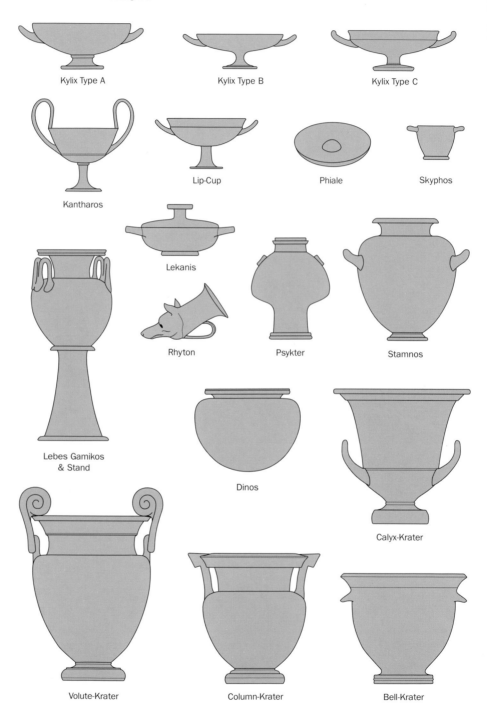

Kylix Type A

Kylix Type B

Kylix Type C

Kantharos

Lip-Cup

Phiale

Skyphos

Lekanis

Rhyton

Psykter

Stamnos

Lebes Gamikos
& Stand

Dinos

Calyx-Krater

Volute-Krater

Column-Krater

Bell-Krater

Exaleiptron

Early
Aryballos

Red-figured
Aryballos

Oinochoe

Olpe

Pyxis Type A

Alabastron

Askos

Kalpis

Squat Lekythos

Shoulder
Lekythos

Hydria

Pelike

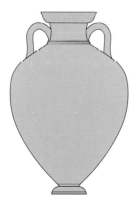

Neck Amphora

Nolan
Amphora

Amphora Type A

Panathenaic Amphora

Amphora Type B

Amphora Type C

Loutrophoros

Index

Note: Page numbers followed by the letter f indicate figures.

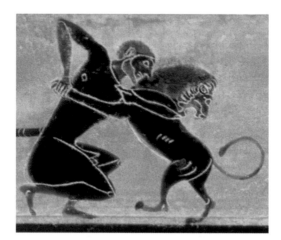

Benedicte Gilman, *Manuscript Editor*

Elizabeth Chapin Kahn, *Production Coordinator*

Kurt Hauser, *Designer*

Ellen Rosenbery, *Photographer* (JPGM objects)

Peggy Sanders, *Illustrator*

David Fuller, *Cartographer*

Typeset by G & S Typesetters, Inc.

Printed by Imago